PRAISE FOR
THE SCIENCE DELUSION

"A symptomatic tour of the real sense of anxiety about the disenchantment of all those qualities that make us feel most alive and unique in the world." —Eric Banks,
The New York Times Book Review

"A series of targeted takedowns of key figures in [the] cultural hegemony of science ... There's certainly a very real need to march on that citadel, because the idea that there can be only one kind of truth has to be deeply damaging to the intellectual development of a culture."
—Mark O'Connell, *Slate*

"His brisk takedowns of Hitchens, Hawking, Krauss, Lehrer and others are sharp and necessary, wielding elementary logic against figures who should know better. [White shows] just how easily good science can shade into the self-aggrandizing ideology of scientism."
—Mark Kingwell,
The Globe and Mail (Toronto)

"A witty critique of scientific overreach that celebrates the totality of human achievement." —*Kirkus Reviews*

"*The Science Delusion* is an important and necessary book."
—*Philadelphia Review of Books*

"White's prose is fluid and often enjoyable … White clearly knows his stuff when it comes to classic literature, and offers an interesting sidebar on the development of Romanticism." —*Willamette Week*

"A bracing and necessary critique by an able arguer." —*Toronto Star*'s Books of Note

"A highly readable yet powerful defense of the importance of the humanities against those who believe science to be the last interpretative framework standing. It is destined to become a classic among artists, dreamers, revolutionaries, and anyone who, like Kierkegaard, believes asking questions to be as important a quest as finding answers." —*Tottenville Review*

PRAISE FOR CURTIS WHITE
AND *THE MIDDLE MIND*

"Cogent, acute, beautiful, and true." —David Foster Wallace

"A splendidly cranky academic." —Molly Ivins

"Not the least pleasure in reading the book resides in the refreshing malevolent irony that transpires from every page. Absolutely indispensable." —Slavoj Žižek

"The most inspiringly wicked social critic of the moment."
—Will Blythe, *Elle*

"Re-visioning the world takes brawling muscle and a sneer. Curtis White gots that." —Andrei Codrescu

"At first, *The Middle Mind* looks simply like this season's lefty screed but where White departs from most liberal ranters is that he doesn't blame the stupidizing of America on brainwashing or sinister corporations. He blames you and me." —John Colapinto, *Rolling Stone*

"A strong, knowledgeable, entertaining (and imaginative!) argument." —John Barth

"A master of bewitchments, parodies, and dazzling tropes."
—Paul Auster

"A sharp, erudite and witty text that ... could help set our country on a path to a saner future." —John de Graaf, coauthor of *Affluenza: The All-Consuming Epidemic*

"A serious effort to understand a serious problem and should find a prominent place in every American library."
—*Library Journal*

CURTIS WHITE is the author of the novels *Memories of My Father Watching TV* and *Requiem*. A widely acclaimed essayist, he has had work appear in *Harper's Magazine*, *Lapham's Quarterly*, *Orion*, and *Playboy*. His book *The Middle Mind: Why Americans Don't Think for Themselves* was an international bestseller in 2003.

OTHER BOOKS BY CURTIS WHITE

NON-FICTION

Monstrous Possibility:
An Invitation to Literary Politics

The Middle Mind:
Why Americans Don't Think for Themselves

The Spirit of Disobedience:
Resisting the Charms of Fake Politics, Mindless
Consumption, and the Culture of Total Work

The Barbaric Heart:
Faith, Money, and the Crisis of Nature

FICTION

Heretical Songs

Metaphysics in the Midwest

The Idea of Home

Anarcho-Hindu

Memories of My Father Watching TV

Requiem

America's Magic Mountain

THE
SCIENCE
DELUSION

Asking the Big Questions
in a Culture of Easy Answers

CURTIS WHITE

WITH A NEW AFTERWORD
AND A Q&A WITH THE AUTHOR

MELVILLE HOUSE
BROOKLYN • LONDON

THE SCIENCE DELUSION

First Melville House paperback printing: August 2014

Melville House Publishing 8 Blackstock Mews
 145 Plymouth Street and Islington
 Brooklyn, NY 11201 London N4 2BT

mhpbooks.com facebook.com/mhpbooks @melvillehouse

ISBN: 978-1-61219-390-8

Printed in the United States of America
1 3 5 7 9 10 8 6 4 2

A catalog record for this title is available
from the Library of Congress.

For Lewis Lapham

It is very advisable to examine and dissect the men of science for once, since they for their part are quite accustomed to laying bold hands on everything in the world, even the most venerable things, and taking them to pieces.

—Nietzsche

CONTENTS

INTRODUCTION

One of the most astonishing spectacles of popular intellectual culture in the first decades of the 21st century has been the "confused alarms of struggle and fight" rising from the clash between the Christian evangelical and the scientist. At the very moment that the neo-cons made the child-minded mythologies of the Christian right the defining ideology of the Republican Party, scientific liberalism produced a series of triumphal books proclaiming the victory of science and reason over religion. The commercial success of these works—led by Richard Dawkins (*The God Delusion*), Christopher Hitchens (*God Is Not Great*), Alex Rosenberg (*The Atheist's Guide to Reality*), Sam Harris (*The Moral Landscape*), and, of course, Bill Maher's lethal dose of pop *sapientia*, the movie *Religulous*—is a "phenomenon," as the book world likes to say. In any case, it is clear that the story these writers have to tell is one that a very powerful part of our culture wants told and emphatically so.

More recently, a separate series of extraordinarily

successful books, lectures, and articles have appeared concerning the advancement of scientific knowledge about the human brain: how it works and how it possesses those mystifying capacities that until now we have called consciousness and creativity. I will be focusing on three science writers—the science journalist Jonah Lehrer and the neuroscientists Antonio Damasio and Sebastian Seung. These writers are, I think, typical representatives of the field, but their work is just a sliver of the total output: between the neuroscientists and their allies among the advocates of Artificial Intelligence, the literature explaining the brain's "wiring" is vast and technically intimidating.

Unlike those scientists and critics at war with religion, it is much less clear that these writers have an antagonist, or are part of our culture wars, but it is obvious that neuroscientists are trying to explain phenomena that until the last few decades were thought to be in the domain of philosophy, the arts, and the humanities. The surprising thing is how much interest and enthusiasm neuroscientists and their advocates have generated in the media and among readers. For example, until his unfortunate fall from grace for lapses in journalistic ethics, Lehrer's *Imagine: How Creativity Works* was a best seller; and Sebastian Seung's TED lecture on the "connectome" has had over half a

million views. There have been a few critiques of this work from academic philosophers like Thomas Nagel (*Mind and Cosmos*) and Alfred R. Mele (*Effective Intentions*), but there has been nothing remotely like a popular response to neuroscience's encroachment on the humanities.

Shouldn't there be voices as prominent as Lehrer's asking very different questions? Are we really just the percolating of leptons and bosons, as philosopher of science Alex Rosenberg believes? Are we just matter obeying the laws of physics? In our emotional lives, have we been for all this time nothing better than the humiliated lover of E. T. A. Hoffmann's "The Sand Man" who falls in love with Olympia, a seductive piece of clockwork? For all these centuries, have our soul mates (as Notre Dame linebacker Manti Te'o called his electronically simulated "girlfriend") been mere congeries of meat, wire, and chemical? Are our ideas best understood as gene-like "memes" for which the most important consideration is not truth but adaptive "fitness"? Is the best way to understand our social behavior by tagging it to genes: the "selfish gene," the violence gene, the altruism gene, the compassion gene, the romance gene, etc.? Most importantly, whether the neuroscientists are correct about all this or not, what are the social and political

consequences of *believing* that they are correct, or nearly so?

So I'd like to ask, "In whose interest do these science popularizers and provocateurs write? And to what end?" They would like us to think that their only interest is the establishment of knowledge. What I will suggest is that their claims are based upon assumptions many of which are dubious if not outright deluded, and that the kind of political culture their delusions support is lamentable. I say lamentable because it is too late to say "dangerous." It's already here and well established.

One thing that can be safely said is that these ideas are not entirely new, never mind the fact that part of the hype is that they are the cutting edge of scientific knowledge. The truth is that the fundamental assumptions of modern scientific culture are part of the ideological baggage of the Enlightenment. In his famous lectures on *The Roots of Romanticism* (1964), Isaiah Berlin expressed that ideology in this way:

> [The view is] that there is a nature of things such that, if you know this nature, and know yourself in relation to this nature, and ... understand the relationships between everything that composes the universe, then your goals as

well as the facts about yourself must become clear to you. . . . About all these things disagreement may occur, but that there is such knowledge—that is the foundation of the entire Western tradition. . . . The view is that of a jigsaw puzzle of which we must fit in the fragments, of a secret treasure which we must seek.

The essence of this view is that there is a body of facts to which we must submit. Science is submission, science is being guided by the nature of things, scrupulous regard for what there is, non-deviation from the facts, understanding, knowledge, adaptation. (118–19)

None of this would have been a surprise to Dostoevsky's spiteful Underground Man, exactly a century earlier, in the famous short story "Notes from Underground" (1864):

"[T]hen, you say, science itself will teach man . . . that he never has really had any caprice or will of his own, and that he himself is something of the nature of a piano-key or the stop of an organ, and that there are, besides, things called the laws of nature; so that everything he does is not done by his willing

it, but is done of itself, by the laws of nature. Consequently we have only to discover these laws of nature, and man will no longer have to answer for his actions and life will become exceedingly easy for him. All human actions will then, of course, be tabulated according to these laws, mathematically, like tables of logarithms up to 108,000 and entered in an index; or, better, still, there would be published certain edifying works of the nature of encyclopedic lexicons, in which everything will be so clearly calculated and explained that there will be no more incidents or adventures in the world. (68)

My claim in this book is that the message of neuroscience advocates is much the same as that of the so-called "New Atheists" and that the two should be considered together. The New Atheists speak on behalf of science just as the neuroscientists do, and the message of both camps is: submit. Confess to the superiority of science and reason. But it is not only to evangelicals that this directive is sent; it is also sent to another historical adversary—art, philosophy, and the humanities. There the directive goes something more like this: the human mind and human creations

are not the consequence of something called the Will, or inspiration, or communion with a muse or daemon, and least of all are they the result of genius. All that is nebulous; it is the weak-minded religion of the poets. The human mind is a machine of flesh, neurons, and chemicals. With enough money and computing power the jigsaw puzzle of the brain will be completed, and we will know what we are and how we should act.

President Obama's dramatic announcement in 2013 that billions of dollars will be spent over the next decade mapping the brain makes it very likely that this narrative will become even more powerful in the near future (if for no other reason than that so much money has been thrown at it). Even now the idea that the brain can be mapped has come to seem inevitable—the next genome project, as many say—so that even criticism from scientists seems unwelcome. For example, Donald G. Stein, a neurologist at Emory University, has commented, "I believe the scientific paradigm underlying this mapping project is, at best, out of date and at worst, simply wrong. The search for a road map of stable, neural pathways that can represent brain functions is futile." (John Markoff, "Connecting the Neural Dots," *The New York Times*, "Science Times," February 26, 2013) I suspect that

Professor Stein's skepticism will be lost in the bustle to get in line for grant money. I'd be surprised if Stein himself didn't find some angle that he could legitimate in his own mind. Who could blame him: in the sciences, grants make careers. But what's interesting about Stein's comment is not only that it questions the wisdom of concentrating so much valuable funding on such a quixotic endeavor; what's even more interesting is that it seems to call into question that foundational Enlightenment story of reality as a vast puzzle. As he says, the paradigm itself is wrong!

The problem is to know just who it is that continues to believe and retell this Enlightenment story. Is this what "science" as such thinks? Or is it just what *popular* science thinks? Or is it simply an abuse of science by people with social and political agendas? I think that to varying (and unknowable) degrees it is all three. It is certainly historically what most scientists in their heart of hearts have thought and still think (in spite of the "uncertainties" of quantum mechanics); it is usually the fundamental assumption of popular science and science journalism; and it is certainly an abuse of the real value of science as one of the great on-going human endeavors. It is, in its essence, science as ideology (or "scientism," as it is often called).

Unfortunately, scientism takes its too-comfortable place in the broader ideology of social regimentation, economic exploitation, environmental destruction, and industrial militarism that, for lack of a better word, we still call capitalism. How the ideology of science meshes with the broader ideology of capitalism will be a consistent interest of my investigations here.

The only remaining question is to what degree Western culture, or some meaningful part of that culture, can free itself from the delusions (for they are delusions) on which the ideology of science is based, and find the resources to compose an alternative narrative about what it means to be human. I hope to show that many of those resources are to be found in the poorly understood tradition of Romanticism. It was that nebulous movement that first challenged science's "jigsaw" view of the world, and yet on what grounds it did so and in the name of what contrary idea of nature and humanity it acted, all that is mostly lost to us now. The Romantic tradition certainly has none of the public presence that science and rationalism presently enjoy. It cannot organize the equivalent of Richard Dawkins's Reason Rally of twenty thousand atheists in front of the Washington Monument. My more modest hope is to begin a process of remembering some part of that worthy movement of

artists, philosophers, and, yes, social revolutionaries in order to see just what they might have to say to us now.

I hope you will find that they can still speak very powerfully to us.

I. WHAT'S A GOOD LUNCH?

First, a parable.

An evangelical and a scientist are taking a hike, and the forest is echoing their eternal refrain—"Evolution!" "Design!" "Evolution!" "Design!"—like the call and response of forest thrushes or a Miller Light commercial: "Less filling!" "Tastes great!"

Gustav Mahler approaches from the opposite direction. He stops before them and says, "There's no need to argue about the origin of this world, these mountains and trees." He gestures grandly as if calling an orchestra to a magnificent *tutti*. "I've composed all this already."*

The evangelical and the scientist look at Mahler as if to say, "What's he doing here?" But then they look where Mahler has gestured and say in unison, "Hey! Look! We're in a forest!"

But this moment of revelation is brief. Their

*Only half jesting, Mahler said words to this effect to Bruno Walter upon his arrival at Mahler's summer retreat in Steinbach am Attersee.

venomous glares soon lock back on each other, and off they march like doomed soldiers to the front. The forest lifts and vanishes as if it were as insubstantial as mist in a breeze, and these men of religion and science are left hanging in air, although they seem not to notice.

In his book *The God Delusion*, Richard Dawkins has a parable of his own. He tells of a talk he once had with Jim Watson, "founding genius of the Human Genome Project."

> In my interview with Watson at [Cambridge], I conscientiously put it to him that, unlike him and [Francis] Crick, some people see no conflict between science and religion, because they claim science is about how things work and religion is about what it is all for. Watson retorted, "Well, I don't think we are *for* anything. We're just products of evolution. You can say, 'Gee, your life must be pretty bleak if you don't think there's a purpose.' But I'm having a good lunch." We did have a good lunch, too. (126)

My question is, "What's a good lunch?" and why would a "product" be interested in it? What's the difference between a good lunch and a bad lunch? Is this something science can tell us about? Is it just a way of talking about competition for scarce food resources (I eat squab, you eat pressed ham)? Or is it the case that in order to know the difference between a good lunch and a bad lunch you have to be something more than a scientist and certainly something more than a product? It would seem so. Don't you have to know about something called "cuisine"? But what's cuisine? And in just what way is it outside of science?

Watson and Dawkins are indulging in a familiar sort of self-satisfied gloating over the simpleminded anxieties of the religious.* What they don't seem aware

*There is perhaps a subtle elitism here as well. The dons enjoy a posh lunch, no doubt enlivened with a very special old port, in the hallowed halls of Cambridge University. Meanwhile, the sods they mock from the Apostolic Church of the Righteous Redeemer in Skunk Holler, Tennessee, fall to over the pork and beans trough. They are no more likely to comprehend the lunch consumed by the dons than they are the complexity of genetics.

But let's give the devil his due. In Jim Holt's *Why Does the World Exist: An Existential Detective Story* (2012), there are times when he writes about physics as if he were Anthony Bourdain: "At the table I ordered monkfish and heritage pork and heirloom beets, and I drank a delicious bottle of a locally produced Cabernet Franc."

I am convinced that physics is hard work and they need the sustenance.

of is the possibility that this moment of gloating and self-satisfaction is also a moment of *thoughtlessness*. What exactly are they saying? Are they saying, "Seize the good lunch for tomorrow we die our purposeless deaths"? A mid-day *carpe diem*? Is that the ethical imperative that follows from the theory of evolution and all of science's "bleak" discoveries about the destiny of the universe?

To a degree, I'm kidding, but Dawkins is guilty of the same sort of thoughtlessness in more serious ways. He writes:

> Natural selection ... has lifted life from primeval simplicity to the dizzy heights of complexity, beauty and apparent design that dazzle us today. (99)

Ordinarily, we pass over this sort of frothy enthusiasm in science writing, especially when it is looking at the cosmos. But isn't it a failure of nerve? If science writers were to be consistent, wouldn't it make more sense for them say something more like, "That? That's the Eagle Nebula. It's nothing special. There are billions of nebulae. Some of them make stars, like we need more stars. We can barely see the ones we've got. Dazzling? I don't know what you mean. It's a nebula."

Wouldn't that be more consistent with their assumption that everything is just a product?

Even if we were to take Dawkins's enthusiasm seriously, shouldn't we at least ask, what do you mean by "lifted"? Is it that you think it's *better* to be human than a primordially simple trilobite or dinosaur? Why? Why is "complexity" a good thing? You say, "Evolution is not just true, it's beautiful," but what do you mean by "beauty"?

For authors of popular science books, feeling dazzled is a consistent response to the grandeurs of the universe. For example, Stephen Hawking writes at the end of his recent *The Grand Design*, "... the true miracle is that abstract considerations of logic lead to a unique theory that predicts and describes a vast universe full of the amazing variety that we see." (181) Perhaps he's using the word "miracle" loosely, but what about "amazement"? What is it to be amazed? What is amazement's relationship to the M-theory that Hawking claims explains the origin of our universe and many more like it?

None of these terms—dazzle, amazement—has anything to do with the practice of science. There is no sense in which this passage is related to the scientific method. Hawking uses an aesthetic terminology without feeling any need to provide an actual

aesthetic. In short, there is an unacknowledged system of extra-scientific *value* at work that science refuses to take responsibility for, either because it is unaware of the presence of the system or because it doesn't wish to disturb its own dogmatic slumber.

Dawkins writes critically of paleontologist Stephen Jay Gould's attempt to provide some explanation for these extra-scientific values. In Gould's book *Rocks of Ages*, he suggests that science and religion are "non-overlapping magisteria," each with its own province: science is for how things work, religion is for ultimate meaning. But, as Gould makes clear, these are not the only magisteria. There is also art. "These two magisteria do not overlap, nor do they encompass all inquiry (consider, for example, the magisterium of art and the meaning of beauty)." (quoted in Dawkins, 78–9) Dawkins, of course, sees no need for religion, but Gould's suggestion that art and beauty are a part of human knowledge passes before him without comment, as if it were something that couldn't be seen.

My point is that Dawkins refuses to consider "beauty" even while happily invoking its reassuring aura. If you suggested to him that his own position, that a human is just a "product" of evolution, provides no explanation at all for why this product

should be dazzled or amazed by anything, I think he would be indignant. And he would not be alone. Remember the wide-eyed and emotional performance of Carl Sagan on his PBS masterwork *Cosmos*? Dawkins even quotes one of Sagan's gushier moments: "When you're in love, you want to tell the world. This book [*The Demon-Haunted World: Science as a Candle in the Dark*] is a personal statement, reflecting my lifelong love affair with science." Wasn't half of Sagan's purpose to teach us about the proper aesthetic or even spiritual relationship with the cosmos? Wasn't the universe something more than a terse given, a product, for Sagan? Without this aesthetic education, might we not say, with Hegel, "The stars, hmmm, a gleaming leprosy in the sky"?*

Well, what's all this gushing amazement about then? Aloof in the disdain of a victor, Dawkins doesn't want to be bothered with such questions. We win, he says. We scientists win. We'll gush all bedazzled and amazed when we feel like it and without any requirement to explain what that's all about. The only thing that's important is this: if you deny our truth, you are a member of that large and contemptible

*Hegel party talk as reported by his friend the poet Hölderlin. Perhaps Hegel was in his cups.

demographic, the stupid.* As for cosmic awe, "Well, you know what I mean." The weakest version of this perspective is delivered by Simon Singh in his book *Big Bang*: "Beauty," he confides, "in any context is hard to define, but we all know it when we see it" (149), from which one might conclude that it had something to do with pornography.

The legendary Richard Feynman takes a shot at the problem in a footnote in his book *Six Easy Pieces*:

> Poets say science takes away from the beauty of the stars—mere globs of gas atoms. Nothing is "mere." I too can see the stars on a desert night, and feel them. But do I see less or more? The vastness of the heavens stretches my imagination—stuck on this carousel my little eye can catch one-million-year-old light.... For far more marvelous is the truth than any artists of the past imagined! (59–60)

Well, to be generous, Feynman does not give me a

*Dawkins even refers approvingly to studies purporting to show a relation between religiosity and IQ. "...the higher one's intelligence or education level, the less one is likely to be religious or hold 'beliefs' of any kind." (129) If that's so, what about a belief in the idea that science is something to fall in love with? Or that the universe is dazzling?

lot of confidence that he actually knows much about what the artists of the past imagined. And it's rather unfair to blame the "past" for not knowing what scientists didn't know until *very* recently: what the stars were made of and how they burn. But that aside, what does he mean by "feel," "imagination," and "marvelous"? He clearly thinks he knows, and he thinks his readers know, but my suspicion is that what he means is both trite and unexamined. To "feel" in this sense comes out of Rousseau and Romanticism, but it is opposed to scientific rationality. Feynman is very assertive, but he doesn't know what he's talking about.

As the Romanticist Morse Peckham observed of the use of terms like "marvelous":

> They make the members of the cultural group who use them have the *affective experience of meaning* without forcing them to go to the trouble of finding out whether they have understood anything or not. These words are the totems of in-groups at the higher cultural levels. They are the equivalent of the insignia of the Masonic Shriners. (*Rage*, 310)

I suggest to you that this is a failure to take evidence, *all* the evidence, seriously. Scientists—Dawkins

included—*do* get weepy-eyed over their discoveries. *I* get weepy-eyed over their discoveries. Who can look at images from the Hubble telescope and not feel something very powerful (although it should be understood that the spectral but completely artificial tinting of the photos helps to create this powerful feeling)?* What I do blame Dawkins and science for is their lack of curiosity about what this feeling of awe means. They claim the feeling, and claim its popular appeal, without thinking that it needs to be "substantiated statistically," as everything else they consider is required to be. Amazement-before-the-cosmos cannot be tested or proved by observation, and it is not predictive of anything other than itself. In the hands of science, beauty is just a tautology, or a *dogma*. The dogma is this: "When you are presented with the discoveries of science, you will marvel at their beauty."

Isn't this part of what every kindergarten trip to the planetarium teaches? This is the solar system, and

*According to the official Hubble web site, "Color in Hubble images is used to highlight interesting features of the celestial object being studied. It is added to the separate black-and-white exposures that are combined to make the final image. Creating color images out of the original black-and-white exposures is equal parts art and science."

To a degree, we learned how to recognize the tinted beauties of the Hubble photographs by looking at 19th-century landscape painting like J. M. W. Turner's "Slave-ship."

this is the proper emotional and aesthetic response to the solar system. You may ask questions about the planets, but you may not fail to be amazed. And if you do fail to see the universe as beautiful, you will be frowned upon by adults. In short, science operates within a matrix of familiar aesthetic values that while not necessarily religious are entirely extra-scientific. And it seems to be entirely blind to the fact. Worse yet, the education it offers young and old is this: you will defer to your betters, those who know, the scientists. If they say the cosmos is beautiful, it's beautiful.

You might think that this would be the place where a little philosophical inquiry could help out, you know, some aesthetics, but you would be wrong. For science, the only thing deader than God is philosophy. As Stephen Hawking puts it in *The Grand Design*:

> Traditionally these are questions for philosophy, but philosophy is dead. Philosophy has not kept up with modern developments in science, particularly physics. Scientists have become the bearers of the torch of discovery in our quest for knowledge. (5)

Amazingly, while the news media rose in scandal over

the possibility that Hawking denied God, his claim for the death of philosophy passed nearly without comment. It was as if the world said, "Yes, well, of course *that's* dead." I suppose that's what philosophers get for not "keeping up," as if they were the slow kids at school.

Hawking sounds sweetly reasonable in comparison to Lawrence Krauss and Alex Rosenberg's scorched-earth versions of Philosophy is Dead. In an interview with Ross Anderson of *The Atlantic* (April 23, 2012), Krauss repeated his earlier claim that "philosophy hasn't progressed in 2,000 years." He added:

> Philosophy is a field that, unfortunately, reminds me of that old Woody Allen joke, "those that can't do, teach, and those that can't teach, teach gym." And the worst part of philosophy is the philosophy of science; the only people, as far as I can tell, that read work by philosophers of science are other philosophers of science.... And so it's really hard to understand what justifies it. And so I'd say that this tension occurs because people in philosophy feel threatened, and they have every right to feel threatened, because science progresses and philosophy doesn't.

Rosenberg (ironically, one of those philosophers of science about whom Krauss is so disdainful) is worse:

> The humanities are nothing we have to take seriously except as symptoms. But they are everything we need to take seriously when it comes to entertainment, enjoyment and psychological satisfaction. Just don't treat them as knowledge or wisdom. (307)

Symptoms? Symptoms of what? And "psychological satisfaction"? What does that mean?

Dawkins's own way of saying much the same thing is even cruder. In a throwaway aside, he comments on Michel Foucault and Roland Barthes by saying that they are "icons of haute francophonyism." (388) But of course Dawkins knows sweet nothing about Foucault. What do any of these science writers know about the history of philosophy before Bertrand Russell? Their comments are merely expressions of an anti-intellectual prejudice. I would go so far as to say that they are a kind of bigotry.

In the end, the problem for science is that it doesn't know what its own discoveries mean. It can describe the long process of evolution, but it can't say how we should judge it. Are these happy facts?

Depressing? Or dazzling? As science historian John Gribbin acknowledges concerning the discoveries of quantum physics, they don't "mean" anything. That is, quantum physics cannot tell anyone what to think about a universe composed of quanta. Fulfillment? Disappointment? Science offers no way of *evaluating* what its methods produce. Gribbin writes:

> People still argue about what all this "really means," but for our purposes it is sufficient to take the pragmatic approach and say that quantum mechanics works, in the sense of making predictions that are confirmed by experiments, so it doesn't matter what it means. (520)

As a consequence, when pushed on the matter by people who persist in wanting to know what it all means, science resorts to a tautology: "What we know is what we do with our reasoning, our experiments, and our instruments. If you want something more than that, go ahead . . . so long as you don't violate scientific methodology as theology, philosophy, and art do." Which is what psychologists call a double bind: science confesses that it doesn't know how to provide

meaning for its own knowledge, but all other forms of meaning are forbidden.

Oh well. In the room the scientists come and go talking of lunch.

While a scientist like Dawkins might be forgiven for not having his philosophic/aesthetic house in order, no such tolerance should be allowed for his notorious comrade-in-arms Christopher Hitchens. In spite of the fact that Hitchens regularly invokes the authority of empiricism and reason—he condemns anything that "contradicts science or outrages reason," and he concedes something that no poet would: that "proteins and acids . . . constitute our nature"—he was not a scientist but a literary critic, a journalist, and a public intellectual. So, you would think that the perspective of the arts, literature, and philosophy would find a prominent place in his thought. But that is not the case. He proposes to clear away religion in the name of science and reason. Literature's function in this brave new world is to depose the Bible and provide an opportunity to study the "eternal ethical questions."

Hitchens's *God Is Not Great: How Religion Poisons Everything* is an intellectually shameful book. To be

intellectually shameful is to be dishonest, to tell less than you know, or ought to know, and to shape what you present in a way that misrepresents the real state of affairs. In this sense, and in Hitchens's own term, his book lacks "decency."*

Like Hitchens, I am an atheist, if to be an atheist means not believing in a CEO God who sits outside his creation, proclaiming edicts, punishing hapless sinners, seeking vengeance on his enemies, and picking sides in times of war. This God and his hypocrite followers have been easy targets for enlightened wit since Rabelais, Molière, Voltaire, Thomas Paine, and our own Mark Twain. Of course, this God and his faithful are still very much a problem politically, and Hitchens never lets us forget that unhappy fact. Our own religious right is real, and international fundamentalism is dangerous and frightening, especially for the sad people who must live with it.

As critics have observed since its publication, one

*You may think that I lack decency for attacking a man so recently deceased, but I do no more than what Hitchens himself did. Speaking of Jerry Falwell, Hitchens pointedly refuses a "compassionate word" for this "departed fraud." For my purposes, I know nothing of Hitchens's mortal existence, never drank single malt into the wee hours with him, and so, as Hitchens remarks of the Greek philosopher Leucippus "nothing important depends on whether or not he actually did [exist]."

enormous problem with Hitchens's book is that it reduces religion to a series of criminal anecdotes. In the process, however, virtually all of the real history of religious thought, as well as historical and textual scholarship, is simply ignored as if it never existed. Not for Hitchens the rich cross-cultural fertilization of the Levant by Helenistic, Jewish, and Manichaean thought. Not for Hitchens the transformation of a Jewish heretic into a religion that Nietzsche called "Platonism for the masses." Not for Hitchens the fascinating theological fissures in the New Testament between Jewish, Gnostic, and Pauline doctrines. Not for Hitchens the remarkable journey of the first Christian heresy, Arianism, spiritual origin of our own thoroughly liberal Unitarianism. (Newton was an Arian and anti-Trinitarian, which made his presence at Trinity College permanently awkward.) Not for Hitchens the sublime transformation of Christian thought into the cathartic spirituality of German Idealism/ Romanticism and American Transcendentalism. And, strangely, not for Hitchens the existential Christianity of Kierkegaard, Dostoevsky, Karl Jaspers, Paul Tillich, Martin Buber, and, most recently, the religious turn of poststructural thought in Jacques Derrida and Slavoj Žižek. (All of these philosophers sought what Žižek calls Christianity's "perverse core.") And

it's certainly not that he didn't have the opportunity to acknowledge these intellectual and spiritual traditions. At one point he calls the story of Abraham and Isaac "mad and gloomy," a "frightful" and "vile" "delusion," but sees no reason to mention Kierkegaard's complex, poetic, and deeply felt philosophical retelling of the story in *Fear and Trembling*. In this way, Hitchens is often as much a textual literalist as the fundamentalists he criticizes.

This case has been well made by others, if mostly in places far more obscure than Hitchens's privileged position on the *New York Times* best-seller list. For example, William J. Hamblin wrote a thorough and admirably restrained review ("The Most Misunderstood Book: Christopher Hitchens on the Bible") in which he held Hitchens to account for historical howlers of this kind:

> In discussing the exodus, Hitchens dogmatically asserts: "There was no flight from Egypt, no wandering in the desert ..., and no dramatic conquest of the Promised Land. It was all, quite simply and very ineptly, made up at a much later date. No Egyptian chronicle mentions this episode either, even in passing.... All the Mosaic myths can be safely

and easily discarded." These narratives can be "easily discarded" by Hitchens only because he has failed to do even a superficial survey of the evidence *in favor* of the historicity of the biblical traditions. Might we suggest that Hitchens begin with Hoffmeier's *Israel in Egypt* and *Ancient Israel in Sinai*? It should be noted that Hoffmeier's books were not published by some small evangelical theological press but by Oxford University—hardly a bastion of regressive fundamentalist apologetics. Hitchens's claim that "no Egyptian chronicle mentions this episode [of Moses and the Israelites] either, even in passing" is simply polemical balderdash.

Hamblin is thorough, patient, relentless, but also, it seems to me, a little perplexed and saddened by Hitchens's naked dishonesty and, in all probability, by his own feeling of impotence. You can hardly blame him. Criticism of this character would have, and surely should have, revealed Hitchens's book for what it is ... if it hadn't been published in *The FARMS Review* of the Neal A. Maxwell Institute for Religious Scholarship at Brigham Young University. Hitchens need never have feared the dulling of his

reputation for intellectual dash and brio from that source.

As Hamblin's case makes clear, even defenses of religion in the publications of university presses are not worthy of the attention of the so-called "new atheists." But what would Dawkins or Hitchens do with a book like Robert N. Bellah's *Religion in Human Evolution: From the Paleolithic to the Axial Age* (Harvard, 2011)? This book is a critique of Western culture operating under the one-sided influence of "theoretic" (scientific) culture, and a historical account of how the theoretic is dependent on the mythic. In a review by Linda Heuman in *Tricycle Magazine* (Summer 2012), she writes,

> Bellah simultaneously undermines our unexamined confidence in the absolute authority of reason and increases our confidence in other kinds of truth. . . . In this view of human development, we are first embodied knowers, then storytellers, and only then analytic thinkers. Reason comes not first but last—it is the newest member of an established team, not the captain but a co-player.

Hitchens's most egregious misrepresentations are

reserved for what he calls, with a great intellectual wheeze, "Eastern religion," as if all the varieties of Hinduism and Buddhism could be lumped together. In his chapter "There is No 'Eastern' Solution" (all ten pages of it) he reduces the religious traditions of Asia to the frauds perpetrated by one famously noxious guru (Bhagwan Sri Rajneesh) and a few gratuitous slanders on the Dalai Lama. On the basis of a sign he once saw at Rajneesh's ashram—"Shoes and minds must be left at the gate"—Hitchens concludes that *Buddhism* is a faith that despises the mind. Never mind that Rajneesh was no Buddhist and barely recognizable as Hindu.

God knows why Hitchens was so irate with Rajneeshism; it was a cult made for the worldly Hitch. The Sannyasa movement was interdenominational and emphasized the importance of capitalism, science, and technology over dogma. Far from being a religious fundamentalist, Rajneesh actually burned five thousand copies of a book, *The Book of Rajneeshism*, purporting to systematize his religion. His Indian critics complained not that he was a fundamentalist but that he was bourgeois. Sannyasa's primary success was as a business enterprise with a surprisingly corporate structure. As Hugh Urban reports, "By the 1980s, the movement had evolved into a complex,

interlocking network of corporations, with an astonishing number of both spiritual and secular businesses worldwide, offering everything from yoga and psychological counseling to cleaning services." (171)

What's more galling for those who actually know something about Buddhism is the fact that Hitchens refuses to acknowledge its rich philosophical traditions. For example, the *Heart Sutra* and its many commentaries unite metaphysics and ethics with a profundity that the West would not begin to achieve until Spinoza. (Even Dawkins is willing to concede that Buddhism shares little with fundamentalist religion, and is instead a meditation on ethics: "There is something to be said for treating these not as religions at all but as ethical systems or philosophies of life." [59]) Nor did he take the trouble to learn about the secular Buddhism advocated by lay scholars like Stephen Batchelor, author of *Confession of a Buddhist Atheist*.

As you might expect, both Dawkins and Hitchens have heard this sort of complaint often. In the preface to the paperback edition of *The God Delusion*, Dawkins defends himself by saying that he was right to concern himself only with fundamentalist perspectives because they dominate contemporary world religion. (A claim he makes no case for. There are still

many and large congregations of liberal Christians, even liberal evangelicals, starting with Barack Obama and Jimmy Carter. And the liberal, even *radical*, Jewish community is famously large, as Michael Lerner's interfaith Network of Spiritual Progressives regularly demonstrates.) But Dawkins and Hitchens miss two important points. First, their critics are not only talking about their scholarly limitations but about their *errors*, errors that a more informed or careful critic wouldn't make. More importantly, not concerning themselves with the liberal or philosophic traditions of religious thought is to ignore an important source for correcting the very real shortcomings of fundamentalism. In particular, restricting the argument to what rationalism and science can claim makes irrelevant the Marx-influenced work of Paolo Freire and liberation theology. Even the papal encyclicals of the last fifty years have consistently criticized the way in which capitalism preys upon the poor (far more consistently than the lapsed Marxist Hitchens). Not to recognize this work is a shortcoming worthy of criticism, however much Dawkins wishes to deny it.*

*The one very public criticism of both Dawkins and Hitchens (or Ditchkens) is Terry Eagleton's attack in *Reason, Faith, and Revolution: Reflections on the God Debate*. Eagleton writes of his Red Jesus, "Jesus did not die because he was mad or masochistic, but because the Roman state and its assorted local lackeys and running dogs

But what I am most concerned with is not Hitchens's sloppy or altogether missing knowledge of theology. What I want to describe is how irresponsible his thinking is within his own professed area of expertise, Western literature and philosophy. I have "four irreducible objections" (Hitchens's phrase): he does not acknowledge, and may not recognize at all, his own brand of metaphysics and magical thinking; he does not admit to the destructiveness of this metaphysic; he ignores the spiritual and anti-rational contributions of 19th- and 20th-century literature and philosophy; and his own thinking is ultimately an expression of faith.

I'll begin with Hitchens's metaphysics. Of course, a large part of his book is devoted to denouncing the stupidity of religious metaphysics, especially the idea that God is an entity outside of the ordinary workings of nature. But Hitchens has his own metaphysical claims, claims for which he seems not to feel any need to create arguments. In opposition to religion he proposes Enlightenment reason. What is "reason" for Hitchens? Your guess is as good as mine. Is it the rules of logic? Is it the scientific method? Is it

took fright at his message of love, mercy and justice, as well as at his enormous popularity with the poor, and did away with him to forestall a mass uprising in a highly volatile political situation."

Thomas Paine's common sense? Some combination of the above? Hitchens seems to feel that, *of course*, everyone already knows what reason is and there is no need to elaborate its function or its virtues. But this "of course" is the marker of ideology, and the ideologist resists examining his own assumptions because to do so would be to make vulnerable his claims to authority. So eager is Hitchens to get on to the next item in his concatenation of religious insults to reason that he can't be bothered to say what he means by the term. The one thing that he does seem to be sure of is that reason is something that shouldn't be "outraged." Nevertheless, there is no real difference between Hitchens's outrage to reason and an evangelical's outrage to God.

Hitchens's second metaphysical claim has to do with conscience. He counters the claim that without religion we would have no ethics by saying that conscience is innate. He writes, "Human decency is not derived from religion. It precedes it."

Well, as Hitchens likes to say, this is "piffle." After all, what is a conscience? Does it light up on a brain scan when we think virtuous thoughts? And if it is innate (and just what exactly does it mean to be innate?) why was Crassus's crucifixion of six thousand Spartacans lined up along the Appian Way from Rome to

Capua in 71 BCE thought by the people of Rome to be an expression of Roman *vertù* and a very good reason to honor Crassus with a full triumphal procession back into the city? Are we to imagine that the citizens of Rome threw garlands in the path of the conquering hero against their better judgment? Are we to imagine that after the celebration the citizens were stung by conscience and were unable to sleep at night? Or did Crassus merely confirm for Rome that it was what it thought it was, a race of masters?

To bring the case closer to home, is our own passionate approval of the most massively destructive social system in human history—capitalism and capitalist militarism—an expression of conscience? Even though our Predator missiles may occasionally (or regularly) fall on children, are we sorry that we have them? Or are we proud of our high-tech ordnance? If you were to go to an air show—the fighter jets and bombers ripping through the suburban sky—and suggest that we'd feel very differently if these machines were bearing down on our town and that we ought to be ashamed of ourselves for allowing them to bear down upon others, how many in that crowd would agree? You'd be labeled anti-American and led to the nearest exit for your own safety. For the rest of the crowd, dissolved in oohs and aahs, our military

power, as with Rome's, is merely the brutal (and "beautiful") confirmation of our superiority.

Finally, isn't Hitchens's own book testimony against his superficial claim that there is something called conscience? He claims that religion is "poison," but is he suggesting that religion made men cruel in spite of themselves? All of them? Millions upon millions of people over thousands of years zealously and destructively defending the faith ... in spite of their own innate sense of good and evil? Isn't it more likely that killing the heathens and the heretics and the free thinkers was always something that could be done in perfectly good conscience insofar as it was done for Yahweh, Allah, or Mother Church? If it weren't for the Predators circling overhead, I think the Taliban would sleep quite soundly, never mind that they'll get up the next day and cut off someone's ear for listening to an iPod.

To say that we are innately creatures of conscience is the same as saying that, as Tom Waits sings in "Misery Is the River of the World," "there's one thing you can say about mankind, there's nothing kind about man." In short, both claims are no better than a prejudice. (If told this, Hitchens would get in a huff and move into debating posture, not unlike the "crane" stance in *The Karate Kid*, while Waits would grin that

sly, slightly inebriated grin of his and say, "Yeah. . . .")
As Wallace Stevens wrote about truth claims of this variety, "The world is ugly,/And the people are sad./. . ./
Have it your way." ("Gubbinal") For Stevens, the good and bad of things was not to be determined by religion, or science, or reason, or by a hispid Marxist-cum-neo-con like Hitchens, but by poetry, which at least has the honesty to acknowledge it is making it all up. Making it all up and yet offering itself with the assumption that if others like its peculiar brand of the good and beautiful they'll follow and leave behind the self-interested culture of virtuous violence they were born in.

And what of Hitchens himself? Where is his conscience when he knowingly falsifies the history of religious and philosophical ideas? Is he not himself an example of how conscience is about what suits one's purposes? Personal ethics tend to reflect cultural ethics, and cultural ethics usually follow tribal interests. For Hitchens, too, has a tribe: the "reasonable," the clean, the well-spoken, the "right sort," the Oxford men, the ones who know and revel in their difference from the ignorant, the slaves, the Baptist rubes, the ones who don't go to Cambridge and don't eat good lunches. Hitchens was of the oligarchs and shared their most intense privilege: the right not to have to

take seriously their own lies and misdeeds.

This is all debatable, of course, and a worthy debate it would be. What's appalling is that none of this seems important to Hitchens. Our sense of "decency" is innate. Period. Have it your way, but I thought the truths you were interested in were based on evidence, and you have none.

As Nietzsche wrote in *Beyond Good and Evil*, "No one is such a liar as an indignant man."

The literature and philosophy of the period after the French Revolution were profoundly skeptical of the claims made by Enlightenment reason. They had seen its work. This literature is supposed to be Hitchens's specialty, although there is *no sign of it in this book*. He should know quite well that for Jonathan Swift scientific reason was "Laputa," the whore (also known as the Royal Society). Following Swift, virtually the entire British poetic tradition coming out of Blake opposed itself not only to religious belief but to what Blake called "ratio." For the Romantics, the primary problem for the future of Europe was not with religion, which it saw mostly as something needing to be re-imagined, but with the voracious claims of reason. The platitudinous Hitchens blandly claims that

literature "sustains the mind" (whatever the hell that means), but the mind it sustains is opposed to his faith in science and reason. And a "faith" it is. Nothing else but faith could be so self-satisfied in spite of its dishonesty and its cruelties.

The crimes committed in the name of reason are no less than those committed by the faithful. In fact, one of the first expressions of a murderous faith in the Enlightenment reason that Hitchens holds so dear was made by French revolutionaries during the Reign of Terror. Dedicated to atheism and the "faculty" of reason, the Hébertists took over the cathedral of Notre Dame and staged celebrations to the Goddess of Reason (portrayed by a comely and, for her critics, profligate actress, Madame Momoro).* The legal massacres committed by the Committee of Public Safety were hand in glove with the Cult of Reason.

Even George Orwell, the writer that Hitchens claims to venerate above all others, did not oppose the monsters brought forth by the "sleep of reason" but those monsters—efficiency, rational totality, social administration—made possible by reason itself. In spite of its obsession with Jews, the horror of Nazism

*According to Thomas Carlyle in his *The French Revolution*, "Mrs. Momoro, it is admitted, made one of the best goddesses of Reason, though her teeth were a little defective."

was not a religious nightmare; it was a nightmare of administrative efficiency. If the Catholic Church's response to the Nazis was inadequate, what of the response of the scientists, technicians, and businessmen at the Krupp corporation, or at I. G. Farben, the German chemical company that collaborated with the Nazis? Even worse, notoriously, Nazi eugenics was based on scientific research done in the United States. The American Breeder's Association (!) was established in 1906 by biologist Charles B. Davenport; his organization emphasized the danger of "inferior blood." Only Hitler's extermination camps caused the American scientific community to have a second thought on the matter.*

In other words, the sleep of reason may create monsters, but so does its wakefulness.

Hitchens does not concern himself with science's bad conscience (or lack thereof) concerning its role in the creation of military weapons or in the ongoing destruction of the natural world. The existence of a group called the Union of Concerned Scientists says a lot: not all of science is sufficiently concerned. Of course,

*This infamous history has been brilliantly pieced together by Edwin Black in his *War Against the Weak* (2012).

there are remarkable exceptions, like the saintly Helen Caldicott of Physicians for Social Responsibility, but far too many scientists leave the ethical meaning of their work to people bereft of moral imagination: the powerful and the rich. Even that most estimable of scientist/humanists, Jacob Bronowski, used his math skills to make the firebombing of Hamburg in 1943 more efficient.

To know this—but of course everybody knows this—doesn't require a deep knowledge of science. You can know it from Bronowski's own second thoughts about the place of science in relation to power. As he says in his sadly forgotten BBC production *The Ascent of Man*:

> I bring in the name of Einstein deliberately because he was a scientist, and the intellectual leadership of the twentieth century rests with scientists. And that poses a grave problem, because science is also a source of power that walks close to government and that the state wants to harness. But if science allows itself to go that way, the beliefs of the twentieth century will fall to pieces in cynicism. We shall be left without belief, because no beliefs can be built up in this century that are not based on

science as the recognition of the uniqueness of man, and a pride in his gifts and works. It is not the business of science to inherit the earth, but to inherit the moral imagination; because without that man and beliefs and science will perish together.

Of course, Bronowski should have known through his own experiences—as a science advisor to England during the Second World War—that his fears had already been realized. Two decades before the appearance of *The Ascent of Man*, Bronowski's close friend, the English novelist/scientist C. P. Snow, had written of the moral slough of science in his novel *The New Men* (1954). On the day after the bomb was dropped on Hiroshima, one of Snow's characters, Hankins, observes honestly and powerfully:

> "The chief virtue of this promising new age, and perhaps the only one so far as I can tell, is that from here on we needn't pretend to be any better than anyone else. For hundreds of years we've told ourselves in the west, with that particular brand of severity which ends up in paying yourself a handsome compliment, that of course we've established ethical

standards which are too high for men. We've all assumed, all the people of whom you," he grinned ... at me, "and I are the ragtag and bobtail, all the camp followers of western civilization, we have taken it for granted that, even if we did not live up to those exalted standards, we did a great deal better than anyone else. Well, anyone who says that today isn't a fool, because no one could be so foolish. He isn't a liar, because no one could tell such lies. He's just a singer of comic songs." (*New Men*, 185)

Dawkins and Hitchens have opened the door for other popular books seeking to extend the empiricist victory. Of particular note is Lawrence M. Krauss's *A Universe from Nothing: Why There Is Something Rather than Nothing* (in which he uses quantum physics to put paid to "the last remaining trump card of the theologian"). As of April 17, 2012, 1,327,200 people had watched Krauss's lecture "A Universe from Nothing" on YouTube. The lecture features three things: 1) really interesting cosmology, 2) a flagrant disregard for logic and the use of words, and 3) jaw-dropping arrogance. The science speaks for itself, but Krauss

needs some help acknowledging points two and three.

I have lived among scientists in a university setting for all of my adult life, and most of them were arrogant in the sense that they tended to be dismissive of every discipline outside of the hard sciences, at least in so far as it came to making truth claims (and requests for research funding). But Krauss takes that arrogance to almost comic extremes, especially in relation to religion. His 2009 lecture, delivered at the invitation of Richard Dawkins, was regularly punctuated with snickering asides either to Dawkins (who introduced him) or to the audience about how stupid religious people are. Krauss begins his lecture with this throw-away barb, "Scientists love mysteries. They love not knowing. . . . And that again is so different than the sterile aspect of religion where the excitement is apparently knowing everything although clearly knowing nothing."

Wow. Nothing. Apparently, the brains of Christians don't even contain dark matter. One has to wonder, though, what "religion" means to him. It would appear to mean conservative evangelicals, the Pope, and people who believe in the supernatural. Like Dawkins and Hitchens, Krauss makes no mention of the work of religious and biblical scholarship or of the last two hundred years of Romantic and existential

religious philosophy. Still, are we supposed to give him (and Dawkins and Hitchens) a pass on all this? Or are they not all in the position of the religious dogmatist who prefers to ignore what is inconvenient to his prejudices? (It does complicate matters if one has to go toe-to-toe with the great Christian critic of Christendom, Søren Kierkegaard.)*

The problem with Krauss's logic is a little more complicated. Krauss's purpose is to explain how, as a matter of *fact*, something can and does come from nothing. The science is very, very interesting: the "empty spaces" between galaxies, the nothing between you and the book in your hand, and the nothing between quantum particles is actually full of the vast majority (70%) of the matter, and thus energy, in the universe. It gives off no light, but it's there exerting gravitational influence on the universe as well as, unhappily, creating the repulsive force that causes the universe to expand and accelerate leading to a time—roughly 1.995 trillion years after the death of our sun—when no other galaxies will be visible from our planet.† Great!

*Interestingly, Krauss does take one pot shot at science in his lecture. He seems to feel that string theorists are nearly as whacked as Christians. Apparently, he is an old-school 3D guy and not 9D like the stringers.

†Krauss says that this is "tragic," but I don't know for whom it will be tragic 1,995 billion years after the death of our solar system. It's

But that's not what the theologians are talking about when they talk about nothing. Assuming Krauss is right about the science—and I assume he is right, fascinatingly so—the problem simply becomes "why are there quantum fields rather than nothing," or "why was there an 'irregular smoothness' in the beginning?" His "nothing" is not nothing nothing; it is the quite full space between somethings. It is free of matter but not free of field and so creates a "condition in space" that can exert force on particles. As the astrophysicist John Wheeler put it, "It occupies space. It contains energy. Its presence eliminates a true vacuum." Moreover, if string theory is to be believed, this "nothing" may even have extra dimensions (five!) that curl subtly back onto themselves, saturating space in proportions a trillion trillion times smaller than an atom.

I get this, and I'm no astrophysicist. So, á la Thomas Frank, What's the Matter with Krauss?

Stephen Hawking indulges in much the same

not at all clear what he's imagining. One thing he's not imagining, it would appear, is that the existence of our universe was always dependent on our consciousness of it. After consciousness is gone, the stars can burn all they want, whether near or far, but not a single star will "shine," and nothing will think that's "tragic." That will be the tragedy of the end of tragedy. For Thomas Carlyle, in the absence of language makers, the universe is simply the "signless Inane."

maneuver. In dismissing the need for a divine creator, Hawking uses quantum physics to argue that the "universe appeared spontaneously, starting off in every possible way." (136) This multiverse theory of creation says that our universe (one of an infinity of possible universes) "grew from the seeds of tiny inhomogeneities [clumps] in the early universe but thankfully contained density variations of about 1 part in 100,000." (156)

So, okay, God didn't make it, the universe came from clumps. Well, then, to echo Chico Marx's "Why a duck?": "Why a clump?" Or "Why a quark?"*

Now, in the later book version of Krauss's lecture, he complains about responses similar to this from the religious. He petulantly writes:

> I am told by religious critics that I cannot refer to empty space as "nothing," but rather as a "quantum vacuum," to distinguish it from the philosopher's or theologian's idealized "nothing."
>
> So be it. But what if we are then willing to describe "nothing" as the absence of space and time itself? Is this sufficient? (xiv–xv)

*That sounds more duck-like.

Unfortunately, the way that Christian apologists use the word "nothing" has been in use in this sense since Thomas Aquinas, so at the very least he shouldn't be surprised that his critics find it a sticking point. But he shouldn't need Aquinas in order to understand the problem. As the first Big Bang theorist, George Gamow, acknowledged in *The Creation of the Universe*:

> In view of the objections raised by some reviews concerning the use of the word "creation," it should be explained that the author understands this term, not in the sense of "making something out of nothing," but rather as "making something shapely out of shapelessness," as, for example, in the phrase "the latest creation of Parisian fashion." (quoted in Singh, 489)

Moreover, Krauss's contention is well down the road from where this argument is usually considered. The question is not usually about clumps, it's about asking, "Why was there an infinitely dense point to bang big? And why, when it did bang, did it release particles (quarks and leptons) in precocious balance

with antiparticles?"* Is it because without this elementary matter, and the protons and neutrons that followed, we wouldn't be around to make sure that everything was properly separated out, tagged, and given its own name?†

In the end, this whole noisome debate is beside the point. As I said, the science speaks for itself. Krauss's book is an enlightening summary of what can be found in many popular science books of the last two decades: the story of the development of science from its classical period (Newton and Einstein) to its quantum present (Feynman and Hawking) to discoveries about the geometry of the universe that no one knew or suspected until the last ten years (discoveries in which Krauss, much to his credit, had a leading role). Krauss tells this story very well, and for lay readers like me it's helpful to have these complex matters explained more than once. But the reason this book could find a publisher and a public was because of its politics, not its science. "This is it! The last nail in the coffin of religion! Read all about it!" Had Christopher Hitchens lived a little longer, he would

*Why didn't it release confetti and party streamers?
†This is a version of what cosmologists call the "anthropic principle" which Krauss expresses like this: "It is not too surprising to find that we live in a universe in which we can live!"

have written the preface, and Dawkins does write the afterword. It is in this polemical cradle that Krauss swings. Dawkins is perfectly clear about it in his afterword. Krauss's book is a "knockout blow."

> Even the last remaining trump card of the theologian, "Why is there something rather than nothing?" shrivels up before your eyes as you read these pages. (191)

What scientist/polemicists like Krauss refuse to admit, perhaps because they think that it creates an opening for their enemies, is that there is any limit on what they can claim to know. Nevertheless, it is true even for science that there are unknowable things—unknowable because not accessible to observation or experiment—chief among which is the question of being's ultimate origin. That is not an invitation for the God-mongers to set up camp where science cannot go (creating a "God of the gaps"). Rather, it is simply one of those matters about which science ought to open itself to other forms of thinking, if not knowing, and it might if it felt a little less besieged.

If it weren't for the politics, I would say that science should be embarrassed by the inequality of the contest with its evangelical opponents. On the face

of it, the situation is less like a "war" and more like a sixth grader smashing a kindergartner's face into mud at recess. But is science really as much at risk as the ferocious rhetoric of its adherents implies? After all, it has powerful defenders in the world of applied science and technology, and beyond that the federal, corporate, and military authorities that both depend on and fund the giant budgets of the sciences ($312 billion in 2006, vastly outspending any other country; by comparison, Germany spent only $59 billion).

The oddity is that these corporate and governmental benefactors often make common cause with the evangelicals when it comes to electoral politics. Much of the oligarchy will vote with the Tea Party and support their candidates and then turn around and give millions to the blasphemers in physics and biology. For example, David Koch funds the PBS science program NOVA while denying climate change and, with his brother, funding the political career of Tea Party governor (and Christian conservative) Scott Walker of Wisconsin. Nor do I hear the demagogues in the current Republican House of Representatives demanding that the budget for the National Science Foundation be eliminated (as they do routinely for the National Endowment for the Arts), or calls from social conservatives for eliminating bio-genetic research at Monsanto or "baby-killer" missiles at Lockheed.

And you won't hear these things so long as corporations and the Pentagon are dependent on science's future accomplishments.

Nevertheless, this state of affairs works very well for science so long as it demurs from noticing certain things like the social relationships I have just described. What would science say if it bothered to notice that its funders (corporate and congressional) also fund or support the PACs of its putative enemy, religious fundamentalism? Really, it's not such a difficult thing to observe, especially for minds brilliant enough to discover sub-atomic things. After all, David Koch's name is boldly stamped in the credits for NOVA. How hard can that be to see? So, while science continues to pummel fundamentalism, the far more destructive work of what C. Wright Mills called the "power elite" gets a pass. Where is Richard Dawkins's book on the almighty, self-correcting Market God? Or on the military-industrial complex that science and technology has made possible? But, then, it's not in science's interest to notice such things.*

*In a January 16, 2013 editorial in the *New York Times*, Krauss complains bitterly that the "best scientists" are no longer responsible for the use of the things, like atomic bombs, that they have created. We need to be "listened to," he laments. For myself, I will listen to Krauss when he organizes a boycott of all science grants offered by the Department of Defense. Until then, I don't think he's serious.

Poor science, attacked so unfairly by the dogmatists, by the Tea Party school boards, and by know-nothing politicians. I have to wonder why they should feel so picked upon, though, since almost every detail of our daily lives has been nailed to the floor by empiricists, technicians, efficiency experts, and "rational choice" economists. Even the red state fundamentalists have plenty of high-tech cars, high-def TVs, computers, smartphones, microwaves, and, in short, a world imagined and implemented by their atheist enemies, the scientists.

II. ROMANTICISM AS COUNTERCULTURE

What we should see in the performances of science writers like Dawkins and Krauss is not only their painfully obvious ignorance of religion. There is also the surprising fact that they are openly hostile to the arts and philosophy; that even when they know the humanities quite well, as Hitchens did, they conveniently forget what they know; and that in the last analysis—weirdly!—they are nevertheless dependent upon art and philosophy when describing the value of science, especially when they are basing this value on the "beauties" and "marvels" of its dazzling discoveries.

Unfortunately, few of us are in a position to set them straight. We know the ideology of science—the idea that nature is a jigsaw puzzle that can be fully known—and we should be aware of the powerful social consequences of this ideology. For example, free-market economists regularly reinforce the idea

that economic markets are natural phenomena, that economics is a nearly complete science of those phenomena, and that if some people suffer for these facts there is not much that can be done about it. In fact, there might even be some justice in their suffering (as in Ayn Rand). But what are these people—poets, philosophers, artists—for whom science seems to have so much disdain? And what possible role could they have in relation to issues related to science?

For the historian of ideas, scholars like Morse Peckham and Isaiah Berlin, the nature of art—in fact, the nature of Western civilization—changed radically with the birth of that social and artistic movement we call Romanticism. It was Romanticism that first challenged the emerging dominance of the scientific and rationalist worldview; it was Romanticism that first saw how this worldview would tend toward ever greater social regimentation; and it was Romanticism that first claimed that art could provide an alternative, a counterculture if you will, to both science and present society. Many, many of us think and live in a way that the Romantics made possible, yet how that is so we couldn't say. It's as if we lived in a world ruled by malignant dwarves (as Nietzsche said we did, thinking, no doubt, of Wagner's Alberich) and they had enchanted us into forgetting our own origins.

The Romantic is surely one of the most misunderstood concepts in Western intellectual history. In fact, few people would associate it with the intellect at all. For most, Romanticism is about long hikes in the mountains, mystic raptures, slightly (or entirely) crazed poets, political naïveté, unhappy love affairs, and an unfathomable inclination to commit suicide because of something read in a novel. The very word "romantic" has become a pejorative, as in "He's an incurable romantic," or "You're just a romantic," etc. This is all mostly the work of laziness and stereotype.

At its inception, Romanticism was about the discovery of a social attitude almost entirely new in the history of Western civilization. Up through the late 18th century, individuals found themselves only in a group identification with tribe, kingdom, church, nation, and, brutally, social caste. Romanticism offered a revolutionary and enduring alternative to being absorbed by the culture into which you happened to be born: alienation. Alienation is the feeling that, as Lord Byron's Childe Harold expressed it, "I stood amongst them but not of them." Though I am English, I am not English; though I am Christian, I am not Christian; I am ruled by a king, but I don't like him, in fact I judge him to be evil; worst of all, I sympathize with those nations (especially revolutionary France)

that are supposed to be our nation's enemies. I don't belong anywhere in my own world. In fact, I see this world for what it is, and it is shameful. In place of this world I feel something nobler within me that poets and philosophers, not soldiers, must make real.

William Wordsworth formed this epochal insight in that monument to the Romantic, *The Prelude*, where he realized that he was an "alien in the Land . . . A Poet only to myself, to Men Useless":

> . . . in the regal Sceptre, and the pomp
> Of Orders and Degrees, I nothing found
> Then, or had ever, even in crudest youth,
> That dazzled me; but rather what my soul
> Mourn'd for, or loath'd, beholding that the best
> Rul'd not, and feeling that they ought to rule.

And yet this sense of being homeless was for the Romantics a source not only of pain but of strength and potential joy as well. At last, they were on the path to being who they really were. They refused to be mere creatures of a fallen culture. They would be heroes. They would be free. They would *create themselves*.

Ordinarily, scholars account for the origin of Romanticism by emphasizing its derivation out of the Naturalism of the neo-classical period (the idea that

nature is always superior to art, and that the best art obeys natural laws), and out of the "cult of Feeling" that produced famously "weeping" novels like Goethe's *The Sorrows of Young Werther* and Henry Mackenzie's *The Man of Feeling*. But this sort of genealogical thinking, treating these intellectual trends as in some sense the "causes" of Romanticism, misses the clarifying influence of German philosophy, a mutation—or "Copernican Revolution," as Kant called it—that seems to appear out of nowhere. It misses the social, intellectual, and artistic break with the past that Romanticism is. This break was first fully understood and articulated by Friedrich Schiller. Schiller's great essays—"On Naïve and Sentimental Poetry" and "The Aesthetic Education of Man"—describe what would define European philosophy for the next century: the dialectic. In Schiller's hands, the dialectic is the logic of alienation, *and it is its cure*. This new mode of thinking emphasizes three "moments":

> We can, then, distinguish three different moments or stages of development through which both the individual and the species as a whole must pass, inevitably and in a definite order, if they are to complete the full cycle of their destiny. (156)

These moments look something like this:

An original Power (usually "Nature") ➔
 (1) A distortion of that Power (civilization/culture)➔
 (2) A contradiction within culture (art)➔
 (3) A new Power (a second nature)

This process ought to remind you of Christianity's spiritual dialectic from original innocence to corruption to redemption to salvation, but in this secular form the dialectic is Romanticism's *genetic signature*.

In this book, I want to employ Romanticism in its intellectual rigor, not its nature mysticism, so let me provide a more detailed account of these "moments." I'll begin with "nature," the ground for the succeeding three moments. Nature is our original power. For Schiller, nature is what we once were but are no longer. It is the time of a lost wholeness that he, like William Wordsworth, associates with childhood. What remains of this lost wholeness is *yearning*, a yearning for a lost harmony, and a longing for its happiness. And yet, Schiller contends, arguing against Rousseau, a return to this harmony is neither possible nor desirable.

That nature you envy in things devoid of reason is not worthy of your respect or your longing. That nature lies behind you, it must forever lie behind you. (192)

At its best, nature provides an ideal: "Our feeling for nature is like a sick person's feeling for health." But this aspect of human nature is lost, and modern man is in a state of permanent regret and grief over the loss.

In Schiller's first "moment," the original power of nature is destroyed by what he calls the "misery of culture." Schiller was one of the first to posit that modern civilization is, in essence, not about prosperity or technological progress; it is about deformed humanity. Here he is in agreement with Rousseau, who wrote that it was society and law that:

[B]ound new fetters on the poor, and gave new powers to the rich; which irretrievably destroyed natural liberty, eternally fixed the law of property and inequality, converted clever usurpation into unalterable right, and, for the advantage of a few ambitious individuals, subjected all mankind to perpetual labor, slavery and wretchedness. (276)

It was Schiller who first fully formalized the idea that humans have a natural potential or capacity for self-realization that is cruelly under-realized in Western industrial culture. It is with Schiller that humanity comes to understand what Freud would call its "discontent" with civilization.

Schiller:

> He possesses this humanity in potentiality before every determinate condition into which he can conceivably enter. But he loses it in practice with every determinate condition into which he enters. (147)

By "determinate condition" Schiller means subjection to family morality (patriarchy), a knee bent to the Church that enforces that morality, a head bowed to the State that ensures the reign of the Church, and a hand open to the "cash nexus" that provides the metaphysical atmosphere for the entire monstrosity.

Schiller continues memorably, elegantly, setting the tone for social resistance that would flow through the young Marx and that rings true to this day:

> [Man] develops into nothing but a fragment; everlastingly in his ear the monotonous sound

of the wheel that he turns ... he becomes nothing more than the imprint of his occupation or of his specialized knowledge. (100)

Little by little the concrete life of the individual is destroyed in order that the abstract idea of the whole may drag out its sorry existence. (101)

With this confining of our activity to a particular sphere we have given ourselves a master within, who not infrequently ends by suppressing the rest of our potentialities. (99)

These ideas are still vividly alive for us in ways both serious and unserious. When Walt Whitman wrote that "what I assume you will assume," he was right. We do assume what he, and Romanticism, assumed. This assumption is now so self-evident to us, especially those with an interest in the arts, that we hardly notice when we read in modern novels, even conventional novels, what was unthinkable before Romanticism. For instance, in one of the best social realist novels of the 20th century, Paul Scott's *The Raj Quartet*, Scott writes this, referring to the Anglo-Indian world of the British Raj:*

*You may remember the BBC serial *The Jewel in the Crown*, based upon the first novel in Scott's *Raj*.

They were predictable people, predictable be-
cause they worked for the robot. What the ro-
bot said they would also say, what the robot
did they would do, and what the robot be-
lieved was what they believed because people
like them had fed that belief into it. And they
would always be right so long as the robot
worked, because the robot was the standard
of rightness.

There was no *originating passion* in them.
Whatever they felt that was original would die
the moment it came into conflict with what
the robot was geared to feel. (442–3)

Originating passion? Domination by the great robot
(the logic of the English class system)? Readers of the
present might respond positively or negatively to this,
but they would be unlikely to say, "Ah, Romanticism
is alive!" But that is exactly what this passage says: the
spirit of Romanticism lives.

On the less serious side, consider how the "self-
help" doctrines of New Age assume that most peo-
ple are lacking in fundamental ways, that they have
undeveloped potential, that the nature of Western
culture is substantially to blame, but that the right
kind of self-understanding can lead to reclaiming

and realizing this potential. While the thinkers of the Romantic era would certainly chide New Age for its gullibility and superficiality, I think it would approve of New Age's egalitarian ethic. Anyone can be part of the Human Potential Movement. While there are certainly larger-than-life heroes in Romanticism, the notion of human capacity is not reserved only for the extraordinary genius. It is not all about Faust, or Manfred, or the superman; it is more generously about the capacities for self-realization that are a *common* human inheritance. As Friedrich Schlegel wrote in *Atheneum Fragment*, 19, "To have genius is the natural state of humanity." From this comes the primary Romantic ethic: allow the genius of all humanity to flower. A century later the Frankfurt School social critic Theodor Adorno would echo Schlegel in saying, "You may think me an old-fashioned . . . thinker, but I am deeply convinced that there is no human being, not even the most wretched, who has not a potential which, by conventional bourgeois standards, is comparable to genius." (132)

Many of the great English Romantic poets were familiar with the strong tendency of family and class structure to deny their individual genius. There is a remarkable pattern in the biographies of Wordsworth, Coleridge, and Keats: they were orphans,

raised coldly by relatives, and then pushed toward uncongenial forms of employment (usually in the clergy, where bright boys of their class were usually put).* They all rebelled against their surrogate fathers, against the work that the world had planned for them, and, grandly generalizing their personal resentments, the whole of the British political, religious, and moral system. To say, as they did, "I want to be a poet," was in essence to say "fuck off" to everything they knew of the world to that point. They were all draft dodgers, blasphemers, and communalists, which is why they lived in fear of prison under the "Sedition and Blasphemy" laws that the Tories established as a means of controlling revolutionaries, pamphleteers, and poets. (A spy was assigned to observe the young radicals Wordsworth and Coleridge. This spy is said to have reported that the two were suspiciously interested in "spy nosey," also known as Spinoza.) They lived impoverished in coteries of like-minded friends (especially the forlorn Keats). Coleridge even planned to

*As a matter of fact, Isaac Newton also fits this pattern. Sent away from his widowed mother to be raised by elderly grandparents, Newton was expected to take over the family farm when he came of age. His rebellion took this form: instead of tending to the farm, he read books while his cows ate the neighbor's crops. Finally, he was allowed to return to school to study science and mathematics. So, Newton too felt the gravitational force, if you will, of the Robot.

create a utopian commune in America, with the poet Robert Southey.

As you will know, our coffee houses and music scenes in cities and university towns still have their fair share of poets, bohemians, beatniks, hippies, and urban hipsters resisting the tidal force of work and conformity. They would not be possible without Romanticism.

Culture may be misery, but, happily, there is art, Schiller's second moment: "... as soon as we experience the misery of culture [we] hear our mother's tender voice in the distant, foreign country of art." (192) Romanticism found an internal contradiction in culture that portended its eventual, perhaps inevitable, self-undoing. Art's primary purpose as antagonist to the "robot" is to "model freedom." "Art models freedom" is Schiller's aesthetic mantra, and it is the Romantic aesthetic in full force. Do you want to know what it feels like to be free? Then live in art. Everything else, the paganism, the pantheism, the nature mysticism, the eros, is an elaboration of this one principal. Art is a counter-discourse, it is a counterculture, or it's not art.

For Schiller art is infinitely "labile": lip-like, mutable, shape-shifting, and protean. It refuses the world

as something already determined. It is a welcoming openness to change, to drift, to wandering. It treats reality as a form of disenchantment and says, "Dissolve! Diffuse! Dissipate! In order to recreate!" (Coleridge)

One of the most revealing examples of this laughing freedom is Beethoven's great Diabelli variations. As Maynard Solomon writes:

> Variation is potentially the most "open" of musical procedures, one that gives the greatest freedom to a composer's fantasy. It mirrors the unpredictability and chance nature of human experience and keeps alive the openness of human expectation.... Its subject is the adventurer, the picaro, the quick-change artist, the impostor, the phoenix who ever rises from the ashes, the rebel who, defeated, continues his quest, the thinker who doubts perception, who shapes and reshapes reality in search of its inner significance, the omnipotent child who plays with matter as God plays with the universe.... It shatters appearance into splinters of previously unperceived reality and, by an act of will, reassembles the fragments at the close. (396)

This is a description of Beethoven the Romantic, much more so than in his attempts to mimic the sounds of birds or a brook in his pastoral music.

The idea that the poem should deny rote form (for Coleridge, the "mechanical") and invent its own appropriate shape in the process of its own creation ("shape as it develops itself from within") is a reflection of the ethical ideal that each part of nature, whether plants and animals or human beings, should become a "true image" of "the being within." Art thus participates organically in the *process* of nature. Art performs the process of self-becoming, of self-exposition, of becoming-what-it-is, that actual human beings living beneath the distorting power of culture are denied. This is the most profound sense in which art is "organic": it seeks its one true moment of consummate existence.

Finally, the third moment of the Romantic dialectic aspires to become something more than a negation, a principled refusal, or a contradiction. It becomes something positive, a new power. It not only is what it is, it *knows* what it is. It transcends the antagonism of social struggle and recognizes itself as Life itself. It understands that its desperate resistance to a civilization that has been brought down on its head is

not merely resistance, it is the Good itself. It has come to recognize itself as its own essential freedom. And it does this through art, Nietzsche's "redeeming and healing enchantress."*

Unfortunately, as Hegel reminds us, this noble journey must take place on the "highway of despair," even if that despair often feels like joy as well. As Wordsworth wrote:

> . . . Ah me! That all
> The terrors, all the early miseries
> Regrets, vexations, lassitudes, that all
> The thoughts and feelings which have been
> infus'd
> Into my mind, should ever have made up
> The calm existence that is mine when I
> Am worthy of myself! Praise to the end!
> Thanks likewise for the means!
> (*The Prelude,* Book I, 343–51)

Or Byron:

*See Herbert Marcuse's sublime interpretation of Hegel's Absolute as the infinity of "play." The Absolute is "free self-externalization, release, and 'enjoyment' of potentialities"; it is "sensuousness, play, and song." (*Eros and Civilization*)

The very knowledge that he lived in vain,
That all was over on this side the tomb,
Had made Despair a smilingness assume,
Which, though 'twere wild,—as on the plun-
 dered wreck
When mariners would madly meet their
 doom
With draughts intemperate on the sinking
 deck,—
Did yet inspire a cheer, which he forbore to
 check.
 (*Childe Harold*, Canto III, XVI)

In other words, thanks for the misery! Suffering is the great teacher. What artists learn from their unhappiness is that the only possible response is to, in a sense, become the world: "Produce! Produce!" says Carlyle. Be the creator of a "New Mythus."

While all this may sound abstruse, in fact it is very familiar to all of us. Much of my enthusiasm for Romanticism is the result of my discovery that I am the way that I am because of it. I grew up in a pre-fab California suburb in the 1950s, a place where uncomprehending alienation, an alienation that didn't know

how to say its name (always the most dangerous kind), was the world and the world was merely a lusterless fate. But I was fortunate to live near San Francisco and the music culture of the late '60s. Simply put, hippy culture, psychedelia, and anti-war dissidence called to me and I ran, laughing, to join it. And now I think I have come to understand that the "counter" in counterculture was impossible without the historic break—the discovery of the pain of alienation and the joy of self-invention—that is Romanticism. I may have thought that I was joining hippy culture, but in fact I was throwing the weight of my little being behind the Romantic appeal to Life. I believe that something very like this has remained the case for those (mostly young, as always) people involved in the "radical" art and social movements since the '60s.

Of course, the misery of culture wears upon us, bears down upon us with its ponderous weight, and will often make us feel hopeless. But as Hegel knew, history is a millennial affair, and Romanticism is, odd as this may sound, a very new presence on the human stage, so impatience or fatalism are neither appropriate nor useful. The trick, as Radiohead expresses it, is to "keep breathing."

III. DNA: A PARASITE THAT BUILDS ITS OWN HOST?

"We will know if there is such a thing as
beauty when we know if there is such a thing
as humanity."

—Friedrich Schiller

I have no argument with Richard Dawkins or Law-
rence Krauss's respective fields of expertise: the sci-
ences of evolution and cosmology. They are fascinat-
ing and, as theories, certainly of a very high order of
probability except, as scientists acknowledge, for the
very outer limits of these disciplines. What I would
suggest is that part of the story of evolution is evolu-
tion's self-transcendence. This transcendence is the
event that Thomas Carlyle called, "Man as symbol-
maker made conscious of himself as symbol-maker."
(*Sartor Resartus*) The arrival of the symbol-makers,
the modelers, was perhaps an even bigger event than

the Big Bang, because without the symbol-makers the Big Bang never happened, for the simple reason that there was no thing to call it the Big Bang. When Einstein suggested in his General Theory of Relativity that light travels at a constant velocity *relative to the observer*, he was saying much more than his admirers typically acknowledge. Yes, the speed of light is constant relative to an observer here or on Mars or on the event horizon of the Black Hole Cygnus X-1, but *what happens if there is no observer?* And what does it mean to be an observer? And just what is an observation? Is it the thing-itself? Obviously not. Is it a pure sense impression uncontaminated by symbolic structures? No, that is unthinkable. It is the essence of human consciousness to engage the world in a way that is thoroughly saturated by one sort of language or another. Now, one can conjure up a universe that goes about its business in a dignified way without us, but even that scenario is dependent on a very human act of *imagination*, something that even the heavenliest of bodies is incapable of.*

*I should say something about how I am using the word "symbolic," a notoriously vexed word that, if the OED is to be believed, has mostly to do with Christian theology. I am using the word in this sense: a structure of signs, whether that means syntax and words, composition and musical tone, equations and mathematical symbols, or all of those and more.

Italo Calvino's collection of stories *Cosmicom-ics* (1968) plays time and again on the perplexity of the relation between being and consciousness. In the story "All at One Point," Calvino explores the memories of one old-timer who happened to be there when "all the universe's matter was concentrated in a single point."

> Naturally, we were all there,—*old Qfwfq said*,—where else could we have been? Nobody knew then that there could be space. Or time either: what use did we have for time, packed in there like sardines? (43)

This is literary play, but the play is about a world in which the differing and the conjoining of thing and symbol is electric with a paradox that is both deeply familiar and easily forgotten. Calvino's resolution to the paradox is this: in all those billions of years, nothing ever happened until something came along with Names for it all. And there's something really comical about that.

Or consider it this way, when hominids became capable of symbols (which is to say, when they became human), they entered upon a new kind of evolution, one that became ever more complex, more

self-knowing, and more independent of biology. Paleontologists in fact have narrowed this moment to a period about 40,000 years ago, at the end of the last great ice age, when our ancestors displaced Neanderthals and other archaics, and human cultures began to flourish.* Richard Fortey writes:

> [W]ithin the compass of a few thousand years more innovation had been achieved than in the previous million years by *H. erectus*.... these "industries" show variation from region to region and, surely, the signature of the craftsman taking pride in his work. (305)

The earliest of the remarkable cave paintings of southern and northern Europe date from this same period. For Fortey, *homo* had crossed the "final threshold" and entered consciousness, "freeing the mind from the confines of mere cells." (308)

Richard Feynman once claimed that "all things

*I would not like to seem to be defaming the Neanderthals. I understand that recent research shows that they shaped rocks as tools, had really sharp spears, and that the women wore dyed clam shells around their necks. For all I know, one of them would have composed the *Principia* if only there were a pencil and paper to hand.

are made of atoms, and ... everything that living things do can be understood in terms of the jigglings and wigglings of atoms." In order to contest this claim one need not be religious. The competition between the Faith Based and the Reality Based excludes another option, an option that was alive well into the second half of the twentieth century: the Metaphor Based. A Metaphor Based interpretation of reality argues, in essence, that through symbolic systems we have created a kind of supernaturalism (or even, if you're brave, a spirit world) that is very different from the supernaturalism of religion.* We are not *homo sapiens* but *homo analogos*, the first creature to live not only in a physical environment of jiggling atoms but in an environment of its own devising. In fact, if we didn't *first* live in the analogue we would never have "known" that we were made of jiggling atoms!

When, for whatever reason, our ancestors were driven from the forests and out into the savannas, they adapted by learning to walk upright. But they also adapted in a way that was unique not just to central Africa but to the cosmos so far as we know: they

*In *Sartor Resartus*, Thomas Carlyle called for a "natural supernaturalism," although he was thinking more of the way in which Romanticism humanizes Christian theology.

hallucinated a "parallel" world because, strangely, they could better survive the real world if they first worked out the details symbolically. Eventually, the symbolic world discovered a kind of autonomy. It discovered its own concerns beyond the imperatives of biology and atoms (whatever it is that they want).

As my earlier quote from James Watson suggests, scientists are weirdly comfortable with the idea that the universe and human life is meaningless. We're just products of physics and chemistry and so is the universe. As John Gribbin writes at the conclusion of his *Science: A History*: "The Earth is an ordinary planet orbiting an ordinary star in the suburbs of an average galaxy," and life is nothing more than "chemical processes." Feynman, hammering out his favorite chord, put it this way: "There is nothing that living things do that cannot be understood from the point of view that they are made from atoms acting according to the laws of physics." (20) (I hope you will agree that this is a very disappointing conclusion for someone who was almost as famous for playing the bongos and going to strip clubs as he was for physics.) But, Gribbin goes on to reassure us, none of this implies the meaninglessness of *science*. That exciting game continues. He

writes, "Who knows what the next five centuries, let alone the next five millennia, might bring."

Clearly, one thing that it won't bring is humility, even though there is every reason that it should. Watson and Crick's ambitious efforts to be the first to describe DNA's double helix wouldn't seem to be about an acknowledgment that they themselves are the result of the jiggling of atoms. No, their ambition is about their *desire* to join science's ranks of Immortals like Newton and Einstein (and bongo man Feynman). It's as if they were saying, "Life has no purpose, but my life had a purpose: I won a Nobel Prize!" So fierce was Watson and Crick's sense of the meaningfulness of being "the first," of winning a Nobel, that they trampled over others, especially Rosalind Franklin, whose crucial x-ray diffraction photographs Watson and Crick used without crediting her. She died without ever knowing that her work had been crucial to the discovery of DNA's double helix.

There seems to me to be a strange disconnect at work here. If everything is the result of atomic processes, wouldn't that include scientific inquiry? Why, then, Gribbin's eagerness, his appetite, his excitement for what the future holds for scientific discovery? Isn't his own enthusiasm evidence of something extra-atomic about the Earth's human inhabitants? There

may be nothing special about our place in the cosmos, but there is something very special about our ability to say so.* The question is, "Of what does this specialness consist?" Knowledge? Facts? Or is it the pleasure of discovering that there is a mutuality, like the mutuality of lovers, between reality and its analogue?

The symbolic is not only oriented toward the Real; it also seeks qualities that are proper to the symbolic world itself. Romanticism tended to call the most important of these symbolic qualities "freedom." For Romanticism, our truest destiny is not only to survive but to realize freedom in human, not evolutionary, history.

And just what would Feynman have to say about the idea of freedom? It either is or is not a property of physical reality (atoms). I have never heard of or seen an argument that freedom is a determination of atoms, or molecules, or genes, or brain chemistry. I would be surprised if there were one. But it is possible to imagine that someone has argued that the human demand for freedom is a consequence of evolution,

*Science thus becomes a version of the liar's paradox ("I am lying"): "I am special because I know that I'm not special."

82

although, again, I've never seen such an argument.* To follow Feynman's strict logic, if we can't account for freedom physically, then we should stop talking about it, just as we should stop talking about our Lady of Lourdes. But of course we're not going to stop talking about it, and we're not going to stop pursuing it, whatever it is that we mean by the word. Which, unless you find *my* logic tortured, ought to mean that there is something lacking in Feynman's mechanistic claim. My suggestion would be that this something lacking is a credible account of our life in the analogue. But I don't want to fall over backward to keep from falling on my face. Perhaps freedom is one of those things, like light, that needs to be understood through what scientists call "complementarity": perhaps the answer is neither entirely material nor entirely symbolic (the two are "dual to each other," in string theory jargon). Which just happens to be what the Romantics thought: freedom is a very human idea that is grounded in nature. (I'll elaborate on this later.)

*I am not thinking here of the endless squabble over whether or not humans have "free will," a debate that Daniel Dennett, a philosopher of science, has recently shaken the dust off of in *Freedom Evolves*. Dennett is, along with Dawkins and Hitchens, one of the most visible New Atheists. He argues that free will and biological determinism are "compatible."

This symbolic world even has a kind of immortality: when you die, the symbolic order that you occupied will survive. This sense of a symbolic immortality helps to explain the intensity of our interest in what ideas—religion, caste, nationalism—will survive us. For example, the anger of the conservative response to the '60's counterculture was fueled by the fear that the symbolic world that had for generations given them an identity might not survive the hippy onslaught. Sadly, this also accounts for much of the angst over the demise of book culture, or of classical music. It's pretty awful, these days, to sit in the audience for a symphony and feel, at the age of sixty-two, that I'm one of the younger people in the hall. Major national orchestras are bankrupt, or annually in the red and ever more dependent on the largesse of ever older patrons. How long does that go on? This, too, is the passing of a symbolic order that some of us once recognized as an important part of the world. We resist the idea that it is dying away for a lot of complicated reasons, some of them really generous, some of them all too self-serving. But if a Tea Party were to form around this issue, I'd run to it placard in hand.

The lesson from these examples would seem to be this: if the real meaning of Culture War is survival of (the fittest?) ideas, it doesn't matter if you're a

southern Baptist or a lover of classical music, it hurts to see your symbolic world dying.

Even more singular, this "supernaturalism of symbols" has allowed us to be creatures of will. We are not simply distant spectators on the world, *we participate in making it.** Since that watershed moment in the history of ideas that we loosely designate as Romanticism, we have been aware that nature is a dynamic organism, ever changing and evolving (in this sense, Darwin was as much a Romantic as a naturalist). In that moment, the founding assumption of the Enlightenment—that mind and nature are isomorphic, or structurally identical—was challenged by the essential Romantic idea that meaning is something that the mind imposes on the world. For the American Romanticist Morse Peckham, "no profounder change had occurred in human life since the development of urbanism." (16)

Romanticism discovered that humans can *participate* in the dynamic power of nature through invention, creativity, imagination, art, whatever you'd like to call it. (You could even call it *science!*) When we

*Even scientists once got this. As John Wheeler said, "The universe does not exist 'out there,' independent of us. We are inescapably involved in bringing about that which appears to be happening." (Quoted in Brian, 127)

artists say that the universe is dazzling or amazing, we don't mean that it is out there separate from us sparkling away. To say that it is dazzling is not a judgment on a thing apart from us, as it usually is for science. When we say that "the starry heaven above" (Kant) is amazing, we say it from within nature, through the "work"—the symphony, the poem, the philosophy— *that is itself part of what is amazing.*

Dawkins seems to like and respect art, and he frequently mentions works ranging from Bach to Wagner, Shakespeare to Evelyn Waugh. But art has no role to play in Dawkins's argument. For him, it is only a "treasured heritage," whatever that means. I fear that, like a good lunch, the "great works of art" are just another class marker to distinguish Dawkins and his confederates from the Baptist rubes. Shakespeare is just an imponderable bangle to decorate the triumph of empiricism. But artists will have none of that. The truth is that since Romanticism, art has proudly fancied itself, in Shelley's phrase, the "unacknowledged legislator of the world," a claim that Dawkins and Krauss must find dumbfounding.*

*Given that he has a book of literary essays titled *Unacknowledged Legislation: Writers in the Public Sphere*, Hitchens was something less than dumbfounded by the idea. But in *God Is Not Great* he makes it clear that his lot is cast with the Enlightenment and not Shelley. In fact, the title of his last chapter is "The Need for a New Enlightenment."

This, I would contend, is the true source of the beauty that scientists see in nature. They took it from poets like Wordsworth and Robinson Jeffers, and from painters like Turner (his dramas of light) and van Gogh (his sunflowers rearing up like godheads; his swirling, starry nights), and, as my opening parable suggested, from composers like Beethoven, Wagner, and Mahler. (Or Keith Jarrett's *Survivor's Suite* or Brian Wilson's "teenage symphony" *Smile* or Radiohead's *OK Computer*. I don't mean to be elitist about it. Pick your own cosmic suite.) When scientists gush about the splendor of the universe, they are speaking like poets, but very bad poets. Bad because they are so incurious about the meaning of their poetry—the claim that the universe is beautiful—and are content with a tautology.

Some scientists have at least tried to think through their sense of the beautiful. As the French mathematician Henri Poincaré (1854–1912) observed:

> The scientist does not study nature because it is useful; he studies it because he delights in it, and he delights in it because it is beautiful.... Of course I do not here speak of that beauty that strikes the senses ... I mean that profounder beauty which comes from the

harmonious order of the parts, and which a pure intelligence can grasp. (quoted in Singh, 19)

So, Poincaré rejects a Romantic understanding of beauty, but he accepts a Platonist/Gnostic understanding (the idea that the beauty of the universe can be perceived by a "pure intelligence" is especially revealing). But the notion is still a tautology: science = delight = beauty. But what is "delight"? There is something splendidly obtuse about such formulations; it's difficult to imagine that the estimable M. Poincaré ever allowed his students to get away with such equations in mathematics. And yet in A.D. 2004 Simon Singh can quote Poincaré, in his book *Big Bang*, as if his perspective were still coin of the realm.

It's very important to say, though, that none of this means that scientists are wrong to say that their work with nature partakes of the beautiful. What it means is that they have no idea why this is true.

Morse Peckham was not only a superb scholar of Romanticism, he was also a student of Darwin. For Peckham, art, human play, the pleasure of the random, is a critical *evolutionary* trait. Our ancient progenitors

survived crises by applying random responses to a given crisis until they found one that seemed to work well enough for present purposes. Even science is a thing that "works well enough." Scientists even have a name for it: "effective theory." Newtonian physics may be inadequate as a full description of the cosmic and microcosmic, but it is *effective* on the scale at which it is asked to work. It is mostly useless on the scale of the universe, and it is useless for working with quanta or strings. In short, its truth and its effectiveness are *relative* to the scale in which it is asked to work.

This should not be surprising. It is standard procedure for this new thing, human consciousness, which has learned that it must be light on its feet in order to function within the randomness of nature. And nature is inflected by the random all the way up and down: from quantum fields (a pasture where, as Einstein reluctantly acknowledged, God plays dice), to the "random walk" of radioactive decay and the molecular "jitter" of Brownian motion, to the ordinary randomness of genetic mutation, to Stephen Hawking's M-theory, in which universes rise and fall from chance aggregates or inconsistencies in a supercosmos of charged particles as if they were bubbles in a thick sauce set to simmer. In fact, one of the most

fundamental laws of Western science is a law of the random: the Second Law of Thermodynamics. This law argues that entropy, the chaotic effect of the expenditure of energy, is always enlarging in unpredictable ways.

The strange thing, of course, is that science itself often seems to act as if the Second Law didn't apply to it. No, science moves from discovery to discovery, triumph to triumph, certainty to certainty. As Lawrence Krauss would have it, science participates only in stately "progress." But if science had to take responsibility for *all* of the entropic consequences of its "pure" discoveries, especially with regard to its ancient consorting with the state, with economic power, and with violence, what then? Beyond the "work" of science is the chaos of its "negative externalities" (as economists say): pollution, degradation of the climate, the mechanizing of human life, the arms industry, and the elephant in the room, thermonuclear warfare.* Entropy is also described as "hidden information," but this is not so hidden—just unacknowledged.

Unfortunately, those most capable of understand-

*Archimedes set the example that would hold constant to the present: he was a mathematician and physicist, but he also invented numerous war machines for the unsuccessful defense of Syracuse in 214 BC.

ing and working within the random—artists *and* scientists—have for the last three millennia been perceived as dangerous by most societies largely because they have tended to ask questions which open the way for new and unwanted possibilities. This is particularly bad because the repression of the random is also an attack on our earliest purely human instinct: our ability to *invent our way to survival.* The lion has simple problems and it solves them with its claws; we have more complicated problems (like needing to be as dominant as the lion and eating whatever other creature we want, but without the big claws), and we solve them by *trying things.*

Take a current example of the consequences of demonizing the random: free-market economies are largely responsible for changing the climate in ways that may eventually make life for humans (and a host of other critters) very difficult. But instead of opening up the floor to "trying things," we are powerless, as if entranced by Gods, to try only what we've already done and what has gotten us into the mess in the first place: more markets! Carbon markets! Green markets! Mistakes, apparently, are for repeating so long as they confirm the fictions of the dominant political order. Even scientists play along with this game and imagine that the only thing needed is better technology. But

those who would suggest alternative ways of thinking about the situation, as some scientists, most artists, and the Occupy Wall Street protestors well know, are demonized as elitist, socialist, and anti-American.

For Peckham, what is needed to confront all forms of social dogma, regimentation, and repression is what he calls "Romantic science." It has been forty years since our last true Romantic scientist, a man for whom the public face of science was also the face of poetry, art, and music. Writing at the same time as Peckham, Jacob Bronowski bravely presented *The Ascent of Man* (1973) in a thirteen-part BBC series and a book of the same title. Bronowski was willing to say what the scientists discussed in this book would choke on. To begin with, the very idea that human history is an "ascent" is part of the Romantic optimism of Schiller, Hegel, and Marx. For Bronowski, science is one aspect of that part of the evolutionary story that went beyond mere biology and became what he calls "cultural evolution." This evolution— or ascent—understands that scientific knowledge is always an analogue (not the thing itself), and that much of nature is the way it is not because of laws but because of accidents. Natural selection may explain the existence of a genus, but it does not entirely explain the existence of hundreds of species of beetle,

discovered by the naturalist Henry Bates in the 1840s, all living in a few acres of English countryside. There are now over 400,000 known species of beetle, a fact that once prompted the famed evolutionary biologist J. B. S. Haldane, when asked what he would say if he could talk to God, to say that God had "an inordinate fondness for beetles."

For Bronowski, nature favors complexity, not unity. A hydrogen-rich star turns to helium, a helium-rich supernova explodes in heavier and more complex elements, and those elements form galaxies, solar systems, and planets like our own before cascading upwards—from molecule to bacteria to blue-green algae mat to plants and animals—and finally to the richest complexity of all: consciousness and a transcendent universe of the symbolic. This symbolic universe is beyond complex: it is excessive, it is profligate, it is infinite. For instance, sex has been the preferred mode of genetic transmission for living things since the earliest life forms. But sex for humans is something of infinite invention, elaboration, and excess, especially that form of sex that Freud called libido, an energy that has been sublimated out in the most fantastic ways through the arts and sciences.

Bronowski was even willing to say that "imagination" is a primary tool of science as well as of art,

and that in any given moment in cultural evolution the primary working metaphors of science will be the primary working metaphors of art as well. In episode eight, "Drive for Power" (echoing Nietzsche's will to power), he argues that the reigning ideas of the industrial revolution *and* Romanticism were that nature was a dynamic unity, a dynamo, in short—*energy*. In episode ten, "World Within World," he argues that atomic physics and cubism shared a fascination with what things are like on the inside. He makes this claim while looking at cubist masterpieces in the home of physicist Niels Bohr, who once said, "We must be clear that when it comes to atoms, language can be used only as in poetry." It should go without saying that science seems to have lost that clarity.

Nature's generative excess, its life in the random, is to be found even in the scientific method itself. It begins with what Richard Feynman confessed was "guessing": "In general we look for a new law by the following process. First you guess. Don't laugh, this is the most important step." Leonard Susskind expresses it this way in his terrific book *The Black Hole War*:

Theoretical physicists often invent new concepts just to play with them and see where they lead. Indeed, back in 1994 when Joe

[Polchinski] first showed me the idea of D-branes, that was precisely the spirit of the discussion: "Look, we can add some new objects to String Theory. Isn't that fun? Let's explore their properties." (389)

Guessing is, of course, followed by measuring the guess against experience, but the source of this experience has its own randomizing influence: scientific instruments generate random information ("noise") beyond the information they were designed to discover (again, a version of the Second Law of Thermodynamics, a sort of information pollution; the instrument does work but never with complete efficiency). To make matters worse, the interpretation of this data requires that scientists determine what is and isn't random, a determination that will be skewed by what they're expecting, or, worse yet, *hoping* to find. (In his 1919 experiment to determine whether or not light bent around massive objects like the sun, Sir Arthur Eddington was selective in his use of data, a signal case of "confirmation bias." In that case his bias turned out to be for the correct answer: light does bend.) And, famously, scientists must bring their conclusions to the scientific community, where they will compete with the conclusions of other scientists in

what Thomas Kuhn and others describe as the culture of science. This culture is notoriously thin-skinned and combative, as the ignoble wars over the Big Bang and Black Holes have shown. Richard Fortey provides this chilling account of professional life in the sciences in his book *Life*:

> There is a popular view that scientific conferences are forums for intellectual exchange, where like-minded colleagues freely swap information, motivated only by a disinterested love of truth.... For most workaday scientists the conference is fraught with danger and frustration, and is as aggressive an environment as any sales convention. Advancement is at stake. The long, long ladder of academe has few promotions. Any wrong-footedness is seized upon with glee by sharp-eyed rivals alert to the possibility that old so-and-so has peaked, and what a pity that he is no longer up to the ground-breaking work he did in 1976. The rule is to acknowledge the seminal work of one of the handful of scientists sitting securely at the top of whatever tree it happens to be, who control the research grants, write the job references, and thus wield much

power. The ideal research paper demonstrates that an idea generated by one of these people can be applied in some new situation … the important thing is to get your name attached to an idea while it is still "hot." Even the conference cocktail party is a kind of desperate bazaar where the ambitious mill around trying to catch up with the latest thoughts. Links are forged, troths given. (247)

Needless to say, any science that denies these realities and insists on its certainties is morally dangerous, especially if it also aligns its ideology of certainty with the ruling ideology of the political state (as it has substantially done). When science flatters itself that it is the last man standing—philosophy dead, imagination dead, and art for entertainment only—it becomes its own enemy. It then puts on the mask of power, grim as the face of Saint Robert Bellarmine explaining to Galileo the particulars of his predicament while sitting in a room with instruments of torture. It is because of these concerns that Peckham and Bronowski insist that science must come to see itself in the artist, and the two should together make common cause against dogma and social regimentation.

Without this collaboration with art in the name

of the random (or the dynamic), science is doomed to moral sterility, or to a nihilism that asserts that there are no values (this is Alex Rosenberg's position), or to groundless values such as "the only value, the only morality, is that which enhances biological homeostasis or the survival of the species genome." In other words, the only value is whatever lends itself to the survival of a scrap of germ plasm. To which one should object, "Well, what's the good of surviving, then? Must I think of myself as the moral equivalent of a virus?" In this view of things, DNA is merely a sort of parasite that builds its own host.

But the worst possibility, never expressed openly, is that science's truest value is whatever assures its own continued social privilege, whatever protects its grants and its fellowships at Cambridge or Harvard, its easy access to what C. P. Snow called the "corridors of power," and, last but not least, that "good lunch."

Perhaps this is what the "two cultures" divide has always really been about: not curriculum, as C. P. Snow claimed, but *class*. From its inception, science has been comfortably situated within and dependent upon the oligarchs. Its early heroes, beginning with Tycho Brahe, were members of the nobility or the landed gentry or had aristocratic patronage, a necessary condition when scientists had to build their own equipment or when to be a professor at Trinity

College meant accepting the truth of the Trinity. Dogma interfered with the work of science, no doubt, but that interference was finally overcome because what science offered commerce and the military was so critical to the future fortunes of the oligarchy. Lip service was paid to the church, but the scientists got money. They still do.

This is not left-wing whining; it is standard history of science fare. As John Gribbin writes in *Science: A History*:

> It is probably not entirely a coincidence that the Industrial Revolution took place first in England . . . one of the factors was that the Newtonian mechanistic world view became firmly established most quickly, naturally enough, in Newton's homeland. Once the Industrial Revolution got under way, it gave a huge boost to science, both by stimulating interest in topics such as heat, and thermodynamics (of great practical and commercial importance in the steam age), and in providing new tools for scientists to use in the investigations of the world. (242)

The Romantic objection to dogma was much more personal. Their unhappiness with the British

caste system, with "who I'm supposed to be and what I'm supposed to do," led them to what Marx would later call a "ruthless critique of everything existing." Much to the poet's disappointment, the scientist made his home with the status quo. To the scientist's chagrin, that home time and again led to collaboration in the grotesque horrors of war, environmental destruction, and political repression (as when surveillance technology is used not on criminals but on dissidents). The evils of this collaboration are so obvious now that examples are not even called for.

Opposed to all this, the Romantic sense of value was given its ultimate expression by Nietzsche when he said that our "ought" was not to be whatever servile thing the world has in mind for us, but to *become what we are*. We are not slaves to work and the dogmas of class, and we are not what the neuroscientists and biologists currently claim: a chemical tautology that seeks only its own meaningless replication. Rather, we are the thing that knows that through language/consciousness we bring everything else into being. We bring not only the eternal things like the cosmos into being, and the world of nature into being, but we bear the future as well. We are not fixed by biology. Through the symbolic we become labile, a shape-shifting god like Proteus who can take on any

natural (or unnatural) form. For an artist, entropy is not a problem of mechanics, it is an invitation to play, to join with the universe's love affair with the random.

When science tells us that we are mere products, or "code," or that our minds are like computer networks, and when we are then provided with lives best fit for machines, some of us despair in large part because the scientific worldview has come to feel repressive, to feel like part of the cause of our despair. We then seek our truth elsewhere, in countercultures of one kind or another, especially the counterculture of the arts, that utopia-in-motion of misfit geniuses, poets, dropouts, bohemians, dandies, and other dissident roles that Romanticism *invented* specifically for the purpose of giving those who despair someplace to go.* The conviction that this "life in the random,"

*This is, in essence, Thomas Carlyle's "philosophy of clothes." When certain "clothes"—whether ideas or literal garments—come to seem hypocritical, unbelievable, or, worst, ridiculous, we seek to clothe ourselves in different ideas and, often, different outfits. When we can no longer bow to the vestments of the church, the dress uniforms of the military, or the Wall Street power tie, we announce our ideological dissent, in part, by dressing differently, just as we saw with psychedelia and punk. In both cases, the clothing and haircuts are a first act of refusal and a first raw articulation of a different worldview.

Carlyle's revolutionary insight was that clothes and, in fact, every other aspect of human culture is structured like a language and carries ideological meaning. He was our first semiotician.

this *freedom*, is who we are leads us to seek not only relief from the restricting (and usually stupid, that is, self-evidently fraudulent) narratives of statesmen, economists, bishops, and, yes, scientists, but freedom to be what we are: the universe's symbolic dynamos, makers of worlds, and hot as any star.

Again, Carlyle:

Of this thing, however, be certain: wouldst thou plant for Eternity, then plant into the deep infinite faculties of man, his Fantasy and Heart; wouldst thou plant for Year and Day, then plant into his shallow superficial faculties, his Self-love and Arithmetical Understanding, what will grow there. A hierarch, therefore, and Pontiff of the World will we call him, the Poet and the inspired Maker; who, Prometheus-like, can shape new Symbols, and bring new fire from heaven to fix it there. (155)

IV. THIS BIT OF
NEURAL MATTER

"We (the undivided divinity operating within us) have dreamt the world. We have dreamt it as firm, mysterious, visible, ubiquitous in space and durable in time; but in its architecture we have allowed tenuous and eternal crevices of unreason which tell us it is false."
—Jorge Luis Borges

Freed at last from the limits imposed by religion, science has extended its ambitions beyond the debunking of Christian dogma. It has now turned its attention to another old competitor, the secular world of the humanities and the arts. This second front in the American culture war has its roots in the decades just after the Enlightenment era, especially in the quickly-matured world of post-Enlightenment scientism led

by "Darwin's bulldog," Thomas H. Huxley. It was Huxley who first sought to describe human mental characteristics, including emotions and social organization, as neurological aspects of evolution.

The recent works I will look at all contend in one way or another that now that science has finished with the last vestiges of religious thought and answered its last objection to the scientific worldview ("why is there something rather than nothing?"), they are free to investigate the artists and all of *their* delusions about human consciousness and the human capacity for creativity. After all, science contends, art has its own gospel of revelation—the quasi-spiritual experience of "inspiration"—and its own messiah: the genius.

Steven Pinker claims in his widely cited book *How the Mind Works* that the mind is a "biologically selected neural computer." He writes:

> I want to convince you that our minds are not animated by some godly vapor or single wonder principle. The mind, like the Apollo spacecraft, is designed to solve many engineering problems, and thus is packed with high-tech systems each contrived to overcome its own obstacles. (4)

And this is just prelude to his later conclusion that art is a "biologically frivolous and vain" activity interested only in critical obscurantism, social status, and the tickling of the brain's dopamine reward system (like cheesecake).

The idea that creativity is a problem for scientists, not poets, is frequently made in the *New York Times* "Science Times." There we find the (often droll) attempt to mechanize consciousness and creativity by laying out its relation to areas of the brain and to chemicals, especially neurotransmitters. Of particular interest at the moment is the neuroscience of creativity. Some scientists now claim to know what parts of the brain are responsible for it, and, using fMRI technology, they can even show it to us in the very act of creation, the brain in genius mode, all lit up like a conch shell with a little Christmas light inside.

The problem is that they haven't said a word about the most ordinary aspect of their work: what is creativity? Or, at least, how are they using the word? So:

"What are you researching?"

"Creativity."

"What do you mean by creativity?"

"You know, creativity. We've found the part of the brain that is its origin."

"Yeah, but what do you mean by creativity?"

"Like, you know, coming up with the answers to crossword puzzles."

For example, in the December 7, 2010 issue of the *New York Times*, the featured science articles focused on "creative problem-solving." Puzzles, one article explained, are about "more than mere intellect" (we don't get a definition of "intellect" either). According to Marcel Danesi, professor of anthropology at the University of Toronto, "It's imagination, it's inference, it's guessing, and much of it happens subconsciously."

Such a claim should require a little unpacking. The study of creativity takes place near the intellect and in something called the imagination? And imagination functions in something called the subconscious? And buzzing around on the periphery of all this is a housefly called guessing? Such an account is as much like neo-Platonism as it is empiricism. The only reason we are open to such claims is because we don't think to ask what these words mean, because the words are so familiar we assume that we already know what they mean. "Oh, sure, creativity, the imagination, the subconscious, go on." Frankly, we the people have no clue what these words mean, not with any precision, and neither do the scientists.

Now, it's one thing to say that these terms are a loose-fitting and very provisional organization of

words, a heuristic cluster of notions intended to help us discern the outlines and force fields of this we-know-not-what that we call creativity. There are very real philosophic and social stakes in that discussion. But it is a very different thing to say that "creativity" is nested in among other parts of the brain and in the interaction in the brain of neurons and chemicals.

The real purport of such research is the following message, offered with a straight face and the driest possible wit, and wordlessly consumed by the general public: "The problem of creativity will find its truth in the scientific method. We can say this because everything finds its truth in the scientific method. We have not quite got it all down, but please rest assured that with patience and a lot of money we will solve this mystery. In the meantime, enjoy these pictures of luminous brain parts. It's not the crab nebula, but it's pretty, isn't it?"

Popular presentations of neuroscience make the bizarre and illogical assertion that the brain is a chemical machine, that brain scans of this machine are beautiful to look at, and that somehow this beauty is a confirmation of the reality of the machine. For example, in the July/August 2012 edition of the *Smithsonian Magazine*, there is a very brief article titled "Order in the Cortex." The author, Laura Helmuth, writes:

Neurons in the brain zip messages to one another along long white fibers called axons. Previously scientists traced axon pathways in dissected animal brains, but now they can see the structure of this amazing information superhighway in a living human organ. Using new software with a technique called "diffusion tensor MRI" that tracks water molecules as they move along the axons, Van Wedeen of Massachusetts General Hospital and colleagues found that the fibers are arranged in a surprisingly regular 3-D grid. For instance, the red axons in the image converge on the purple pathway at a 90-degree angle. Axons are interwoven like "the warp and weft of a fabric," the researchers say, with the pattern bent along the brain's convolutions. "It's really pretty, all the little loops and folds," Wedeen says.

Dominating the page is a colorful photograph of neurons spread out within a skull like a Mohawk haircut. No effort is made to remind the reader that the image is not a real picture of anything and that the bright coloring is pure invention, although at the bottom of the page Wedeen is given credit for "artwork."

In the meantime, we are to enjoy the prettiness of it all and accept the claim that the brain is an "information superhighway," in other words, a computer.

Deprived of its cynical bonhomie, neuroscience's assumption that there is no need to justify—beyond the prettiness of it all—its claim that the brain is a machine is like the reasoning of an ancient army to a city it has overwhelmed: "Sure, we've broken every common law of decency, but we are vindicated by the Right of Conquest. As for the idea that you have a grievance, that's quite impossible because, this may come as a nasty shock to you, but 'you' don't exist anymore." As I discussed earlier, for science the perspectives offered by philosophy, poetry, art, and certainly any kind of spirituality don't exist. For science, the idea that nature, humans, and even formerly intimate things like creativity are all mechanical goes without saying. So, if you would-be philosophers or artists have a problem with scientists treading on your turf, or with their use of undefined terms and breathtaking lapses in logic, you're out of luck. In fact, in most popular presentations, science is reluctant to acknowledge that the humanities *ever* existed, except as an embarrassment. They are no more than the residue of some long-defeated enemy: the ignorant past.

• • •

And yet, the claims by neuroscience to have the best possible explanation for that thing we call creativity has demonstrated enormous popular appeal in a series of popular books and presentations, some of which have been best sellers. Notable among these works is Jonah Lehrer's *Imagine: How Creativity Works* (2012). According to Lehrer, the consensus among neurophysicists is that creativity is not something that comes to us from the outside (from Muses or from a magical "Eureka!" factory). As Lehrer expresses it:

> [T]he material source of the imagination: the three pounds of flesh inside the skull ... for the first time, we can see the cauldron itself, that massive network of electrical cells that allow individuals to form new connections between old ideas. We can take snapshots of thoughts in brain scanners and measure the excitement of neurons as they get closer to a solution. The imagination can seem like a trick of matter—new ideas emerging from thin air—but we are beginning to understand how the trick works. (XVII)

This is recognizably the sort of popular science journalism over which the media goes doe-eyed with

admiration. So deferential are these organs to such claims that it is as if no other credible points of view existed, or that the only other points of view, like religious faith, have already been so completely discredited that they don't need to be mentioned. So riveting are the most recent technical advances in science that skepticism is unneeded and mostly unwelcome.

Nonetheless, there are problems, and Lehrer's book is full of them. First, the language of Lehrer's basic description of what he and neuroscience are claiming is riddled with unsupportable, even unfathomable, claims. The claim at the heart of the book is that creativity is "that massive network of electrical cells that allow individuals to form new connections between old ideas." In short, creativity is re-wiring. Now, it is obviously true that human brains created integrated circuitry and they created the wonder of microchips, but Lehrer and, from what I can see, most others in neuroscience and in the Artificial Intelligence community feel comfortable in *reversing* the relationship and claiming that, actually, the human brain is simply a reflection of the super-complex electrical circuits it has created. Unfortunately, it seems never to occur to these good people that the brain-as-computer is only a metaphor.

Metaphor in place, Lehrer is free to state things

that would be laughable out of the context of his book. Lehrer states that scientists can "take snapshots of thoughts in brain scanners." They can? Snapshots of thoughts? What kind of thought can have its picture taken? Sure, as Lehrer says next, you can capture images of the "excitement of neurons," put them in the family photo album if you want, but that is not a thought, at least not when I'm thinking.*

Lehrer himself exposes the problem with supposing that brain scans provided by fMRI reveal the origin of creative thinking. He writes of Mark Beeman's research into higher brain function at the National Institutes of Health:

> Beeman was now ready to start looking for the neural source of insight. He began by having people solve the puzzles while inside an fMRI machine, a brain scanner that monitors changes in blood flow as a *rough correlate* [my emphasis] for changes in neural activity. (15)

Two pages later Lehrer writes that Beeman's analysis of his fMRI scans led to the discovery of the anterior

*In fact, as you can see, I'm furiously thinking right now, and I'll bet if you scanned my brain it would look like the barn had caught fire, but that's not what I'm *thinking*.

superior temporal gyrus, a "small fold of tissue, located on the surface of the right hemisphere just above the ear." But once again Beeman's claim is limited by the fact that he has found, in Beeman's words, only the "neural correlate of insight."

A correlate. Not a "snapshot" of the thing-itself surprised in deshabille, just a correlate. But a correlate of what? That's the hard question that Lehrer simply ignores. Is it correlated with another unseen part of the three pounds of flesh?, to something spiritual?, or to something that is simply unknown or unknowable? The fMRI provides a ghostly trace, not the Thing wriggling on the end of a pin. Lehrer wants to assume as fact that the mechanical origin of insight ("squirts of acetylcholine," as he says later of the inventions of dream) has been found and that all the old mythologies—which, at least, had the modesty of knowing themselves as metaphors, as correlates—are dead to us. But the truth is that neuroscience is wonderful in the way that the Hubble telescope is wonderful. Its investigations into the structure and organization of the brain are fascinating, but it no more tells us of the origins of consciousness (or creativity) than the Hubble tells us of the origins of Being.

Of course, Lehrer is not alone in ignoring this fact. Most neurologists work with the assumption that

their material discoveries are the source of all forms of consciousness and creativity, or close to it. For example, neurophysiologist Benjamin Libet contends that the brain makes its decisions about a third of a second before the person becomes aware of the decision, leaving free will only about 100 milliseconds to weigh in on the matter at hand. (I will not pursue the unhappy question of how this person became separated from his brain.) Even more extreme, psychologist Daniel Wegner, another leading voice in the field, argues that "conscious will is an illusion ... in the sense that *the experience of consciously willing an action is not a direct indication that the conscious thought has caused the action.*" The equivalent idea in Lehrer comes in dramatic passages like this one concerning the invention of masking tape (of all things): "And then, late one night in his office, everything changed. In the time that it took to have an insight—that burst of gamma rays erupting in the right hemisphere—[Dick] Drew grasped the solution to his sticky problem." (26)

I wonder if that's what Lehrer felt as he created his book: a squirt of chemical here, a little quiver in the old ASTG (anterior superior temporal gyrus), a flicker of electricity between the moving parts, and, *voilá,* a happy shower of gamma rays. Is that what he was thinking when he pulled himself back from his work,

celebratory IPA in hand? Or was there a moment in which Lehrer suspected that the very performance of his book was an argument against its conclusions? Did he never ask, "Can this expression of my will, my production, *my book*, be a mere chemical squirt?" It is profoundly saddening, even more saddening than his journalistic sins, that he never once paused in order to encourage his reader to ask such a question.*

Lehrer emphasizes that creative brain function is not just reserved for artists and "creative types," even though he frequently mentions artists like Beethoven, Bob Dylan, and the poet W. H. Auden. Creativity is a shared human capacity. (No argument there.) But, like so many other books in recent years (in particular, Richard Florida's *The Rise of the Creative Class: And How It's Transforming Work, Leisure, Community and Everyday Life* [2002]), Lehrer's best examples tend to come from creativity as it works within corporations, whether Procter & Gamble, 3M, or Pixar. As a

*In the summer of 2012 Lehrer was embarrassed in two separate incidents. In the first, he "self-plagiarized" by presenting old work as new for *The New Yorker*. A few months later he was accused of inventing quotes by Bob Dylan in *Imagine*. Eventually, his book was withdrawn from circulation by his publisher and he resigned from *The New Yorker*.

Fresh Air segment on NPR put it, *Imagine* (with its egregiously inappropriate association with the John Lennon song) is about "Fostering Creativity in the Workplace." Lehrer begins his book by describing the process that led to the creation of the Swiffer mop at Procter & Gamble. Procter & Gamble accomplished their product coup, the revolutionizing of the mop, by outsourcing its creative needs to creativity specialists, the "envisioneers" at Continuum Innovations, a design firm in Boston and LA. Continuum CEO Harry West said of the Swiffer project, "They told us to think crazy." They did, and they came up with "one of the most effective floor cleaners ever invented."

This is not satire. No one is laughing about the absurdity of a notion of "creativity" that links Bob Dylan to Swiffer mops. We are truly meant to be excited about the liberation of creativity in the workplace, and we are certainly meant to be excited that leading the way is the ever-enlarging world of neuroscience that has set aside old illusions about the Muses and put in their place the softly glowing illumination of the human brain firmly held in its creative harness. One gets the feeling that for Lehrer the work of these neuroscientists is itself an example, maybe the supreme example, of discovery and creativity.

The logic of this science would seem to be this:

because brain scanners can measure the "excitement of neurons" in the same parts of the brain for both artists and mop inventors, the activities of artists and mop inventors are the same so far as science is concerned. Best yet, science offers the possibility of learning how to engage and train these creative areas of the brain. In the "workplace" of the future, we'll all be geniuses. The cutting-edge, high-def stereo system will be playing "Maggie's Farm" at just the volume that neuroscience has determined to be maximally conducive to bubbling invention. The techno-hip will be circulating in the commons, freed from their cubicles at last, ideas flowing from them like colorful robes. Thus the ideal corporate ambience, where it need never be doubted that the neuroscience, the rock 'n' roll, and the mops of the future will find a warm home.

But there's something missing in Lehrer's triumphant account. The polite way of identifying this something missing would be to say "social context." The more agonistic way would be to say that *for the last two centuries artists have hated mop inventors.* Beethoven, one of Lehrer's favorite examples of human creativity, seemed to hate just about everyone, and wrote his music against them, against his father, against Haydn, against "innkeepers, cobblers, and tailors," and against the philistine nobility that paid his

wages. In short, Lehrer either has never heard of or simply dismisses the role of social alienation as a driving force for what he blandly calls creativity.

Lehrer has nothing at all to say about the obvious fact that most historical change in the arts, the movement of art movements, has been social in character and not simply change for creativity's sake, just for the pleasure of setting the old neurons buzzing, let alone for the sake of boosting a corporation's bottom line. To read Lehrer's version of things one would think that creativity happens simply because our brains have fun finding "solutions" and when they do find solutions they get all lit up like an Xbox action game. (Actually, it's worse than that: according to Lehrer's logic, the lighting up of neurons *is* the solution.) I'm sure that at Continuum Innovations, as at the hipper Silicon Valley ventures, the employees have dreadlocks and pierced tongues and tats and company-provided skateboards and cruiser bikes for lunch breaks. This fake bohemian geek culture acknowledges the essentially dissident character of art even while betraying it.

But the corporate types, the suits, are under no illusions about the bohemian substance of its "creatives." Lehrer approvingly quotes Dan Wieden, founder of the advertisement agency Wieden + Kennedy:

"You need those weird fucks. You need people who won't make the same boring, predictable mistakes as the rest of us. And then, when those weirdos learn how things work and become a little less weird, then you need a new class of weird fucks. Of course, you also need some people who know what they're doing. But if you're in the creative business, then you have to be willing to tolerate a certain level of, you know, weirdness." (172)

What the weird fucks think of being brought in, milked of their weirdness, and then pushed back out

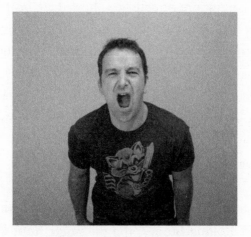

One of the "weird fucks" at Continuum

on the street as the next year of weird fucks takes their place is not commented on and seems not to be a matter of concern for Lehrer or, obviously, for Wieden. I suppose they move from the workplace to the workforce to the labor market, where they are agglomerated with other unemployed weirdos wandering the streets.

Of course, it's not all about weirdos in the workplace. Lehrer devotes a chapter ("Bob Dylan's Brain") to music. Lehrer is particularly interested in the moment in which the folkie Dylan reinvented himself as the rock 'n' roll Dylan. How did this transformation happen? Lehrer writes:

> The question, of course, is how these insights happen. What allows someone to transform a mental block into a breakthrough? And why does the answer appear when it's least expected? This is the mystery of Bob Dylan, and the only way to understand the mystery is to venture inside the brain, to break open the black box of the imagination. (8)

The moment in question is the creation of the song "Like a Rolling Stone," the hit single from Dylan's

album *Highway 61 Revisited*. According to Lehrer's version of the story, Dylan was bored with what he'd been doing, trapped between his own public image as the writer of protest songs and the lame platitudes of Top 40 music. So, he retreated to Woodstock and began to let his unconscious do the work,* from which emerged "Like a Rolling Stone." Lehrer writes, "The story of 'Like a Rolling Stone' is a story of creative insight. The song was invented in the moment, then hurled into the world." (23) The song would "revolutionize rock 'n' roll."

I have a simple question for Lehrer: So what? Why is it good to revolutionize rock 'n' roll? Who cares? For Lehrer it's just another instance of the human capacity for "insight." It is also, as with the Swiffer mop, another example of "success"; the song leads to the creation of more songs by other artists, like Jimi Hendrix, that are popular and make everyone a lot of money. Why, people become *famous*!

The creation of the song is not about the history of rock, and not about the brain's need for insight, and certainly not about being successful like the proud people at Continuum Innovations. Well, what should

*With at least a little help, it must be said, from marijuana.

we say, then? Without discounting the deeply plea-
surable and ineffable *je ne sais quoi* of Dylan's musical
self-invention, for me the song is "about" its formal
freedom, its raw difference from pop and folk music.
It is also about the thrilling invention of a self, this
new Dylan, who can walk away from the wreck of the
culture of that moment, taking his "fans" with him.
In short, as Friedrich Schiller put it in 1795, Dylan's
song "models freedom." Dylan proposes, "Hey, this
is what freedom feels like to me. This is what being
alive feels like to me. What do you think?" The song
is a proposition, a seduction, and its triumph is that
it was such a wildly successful seduction. In other
words, Dylan's music (especially, for me, "Visions of
Johanna" and "Desolation Row") argues, "Can you
return to being in the world in the way you were in
the world before you heard this song?"

For those, like Lehrer, who do return to the world,
Dylan's judgment is this: "Your sin is your lifeless-
ness."

All of the "real thing" rock bands of the last forty
years asked this same question. The Dead asked it, the
Ramones asked it, XTC and the Pixies asked it, Ra-
diohead asked it, and the Elephant Six bands of Ath-
ens, GA, continue to ask it (especially Kevin Barnes

of Of Montreal).* The answer to the question is not necessarily a yes or a no. More than anything else, the question's purpose is to create *yearning*: the recognition of our own dissatisfaction with things as they stand and the creation of the possibility of a future happiness. Because now we know, thanks to this music, something about what that happiness might feel like.

As Morse Peckham writes in *The Romantic Virtuoso*:

> One of the most common themes of German Romanticism is . . . yearning. To the question, Yearning for what? We have already encountered the answer: yearning for a condition of existence that transcends the present one, more specifically yearning for a culture that transcends the failures of the culture then available. (59)

*"Boredom murders the heart of our age / while sanguinary creeps have the stage / boredom strangles the life from the printed page." (Of Montreal, "Forecast Fascist Future," *The Sunlandic Twins*) The best lack all conviction while the worst are full of passionate intensity? And all with brutal guitar riffs and a very danceable rhythm!

But, for Lehrer, Dylan is just another famous example of a "creative problem solver" no different from Milton Glaser, creator of the insipid "I ♥ NY" logo. He throws out the social, ethical, and aesthetic dimension of art for a few full-color brain scans and the instruction: go to work.

Imagine is a typical example of what I have elsewhere called the Middle Mind. In the Middle Mind, unpleasant distinctions are not made. One prefers to think that everything is good and that it is unnecessary to suppose that Dylan is somehow better than or, heaven forefend!, opposed to the creators of Swiffer mops. We all have a role to play! We are all part of Team Creativity USA! We should be proud, for we have made the Creative Economy the envy of the rest of the world, where people have regular jobs, obstructionist unions, and are the furthest thing from our hipster Envisioneers.* So, why would you want to say that when your neurons light up composing music they're any better than my neurons lighting up when they create a new logo for a tennis shoe? Aren't we both just doing it?

*Could they organize as the Congress of Industrial Weirdos? The American Federation of Weirdos?

As I wrote in *The Middle Mind* when discussing Richard Florida's notion of a creative economy:

> ... the arts are a necessary part of the Creative Economy because creative workers (read: software engineers [or mop inventors]) demand the stimulation and experience of music and theater just as much as they demand an afternoon latte. Art is a lifestyle amenity that is tolerated and encouraged by business because it is, in the final reckoning, profitable.... Any art that is "stimulating" enough to make the creative workers happy and profitable is good art by this logic. So central is stimulation to art's social good, from Florida's perspective, that you'd think he had it confused with coffee. (159)

But why feel surprised by any of this? So complete is the victory of Lehrer and Florida's perspective that it is the assumption now even of arts councils and, as far as I know, the artists they fund. Who knows how to defend art in itself? Certainly, we hear the pious lamentations of state art councils and their well-meaning members. Imagine this dialogue between an arts council board member and a "difficult" person like me:

"Oh! Art! We must save it!" she says.

"Really? Why?" I ask.

"Well! Because it's so beautiful, of course!"

"Can you please stop talking with exclamation marks? You're as bad as a Tea-bagger going on about the federal deficit."

"Sorry! If not because it's beautiful, then because our children ought to learn to be creative."

"Why?"

"Because that's nice, don't you think? Are you trying to confuse me?"

If you have a bullshit detector, these "reasons" should set it off, even if you also think, "Oh, let her say what she likes, the moron, since it's in my interest. I think. Maybe I can get one of those arts council grants."* But surely there are reasons that are not bullshit. Let's look. Here are the Top 10 Reasons to Support the Arts as determined by the organization Arts Watch in the year of our Lord 2011:

10. They foster creativity and beauty.
9. They build strong communities.
8. They produce health and shorter hospital stays.
7. They create a 21st-century workforce.

*Disclosure: I have received two state arts fellowships and one federal. I am a cynic and an ingrate.

6. They improve academic performance.
5. They improve SAT scores.
4. They stimulate industry.
3. They stimulate tourism.
2. They stimulate the local economy.
1. And, tada, they are a profitable industry themselves.

So, while the top four reasons are economic (and redundant), and the next two are related to economic development (and redundant), and number seven reads as if it were plagiarized from Richard Florida, and numbers eight and nine are dubious and vague (in that order), only one, the lowest, is an expression of something an artist would recognize, dimly, but even that one is an empty tautology.* After all, what is beauty? (To judge from the rest of the list, it has something to do with the GDP.) To say that the arts should be supported because they're beautiful is not much different from saying that they should be supported because they are a sandwich. At least you can eat a sandwich.

All of this ignores with ungulate placidity the fact that those arts at the inception of the modern era,

*The General Electric Corporation has captured the real meaning of this list in a slogan: "GE: Imagination at Work," rhetorically identical to the Nazi's *arbeit macht frei*: work makes you creative!

the arts of Romanticism, began as a rejection of the economic systems in place at the time (whether the gentry and their rents or the industrialists and their quarterly reports). The founding emotion of Romanticism was *hostility*, not some abstract longing for beauty. And alienation. Alienation *first*. And anger. Then came their peculiar but searing beauties.

What is spectacularly missing in all aspects of Lehrer's account of human creativity is the obvious fact that neurological activity is, so far as we know, an effect and not a cause of anything. At best, the neuroscientist may assume that the true cause of the effect (brain activity, "excitement" among the neurons) is to be found in the same part of the brain, another mechanical feature just beneath the surface firing of neurotransmitters. But when the neuroscientist thinks in this way, he is little better than Hegel's phrenologist who says, "You are this kind of person because your skull-bone is constituted in such-and-such a way," and this means nothing else than, "I regard a bone as your reality." We are now in the position of saying, "I regard a chemical equation as your reality."*

*See Leonard Mlodinow's jaw-dropping version of this in *Subliminal: How Your Unconscious Mind Rules Your Behavior*. Mlodinow

You may think that this is mere wicked satirical excess on my part. You would be wrong. In neuroscientist Sebastian Seung's *Connectome: How the Brain's Wiring Makes Us Who We Are*, he calls the emerging science of "connectomics" a neo-phrenology. Seung writes, "Phrenologists explained mental differences as arising from variations in the *sizes* of the brain and its regions. By imaging the brains of many human subjects, modern researchers have confirmed this idea, using it to explain differences in intelligence.... They have found some of the strongest evidence we have for the idea that minds differ because brains differ." (xix) What's next, Lamarckism? Actually, yes. As neurophysicist Antonio Damasio observes in passing,

argues that our behavior is "ruled" by chemicals the existence of which we are unaware of. So, "women ... dress sexier not because they consciously decide to but because their hormones tell them to." (One wonders what Neolithic women made of these hormonal instructions. An extra layer of beads and a tuft of beaver fur, perhaps.) Mlodinow concludes, "Today, with researchers' new ability to watch the brain at work, helping to understand the origins and depth of the unconscious, vague terms like *id* and *ego* have given way to maps of brain structure, connectivity and function." It's true that Freud argued that the riddles of the unconscious would eventually be answered by biologists. Well, now we know that nerve fibers send signals to the brain; the brain secretes vasopressin or oxytocin; and the bewildered male gets a raging hard-on and wonders, "WTF?" If Freud were still among us, wouldn't he be just a little disappointed as he wadded up *Oedipus Rex* and aimed for the corner wastebasket?

"There is growing evidence that, over multiple generations, cultural developments lead to changes in the genome." (29) So, soon we will be passing on multitasking genes? And faster thumbs for texting? Or smaller ear canals for ear buds? (I will have much more to say about Seung and Damasio shortly.)

As far as I'm concerned, all of these learnéd suppositions of "modern researchers," firmly based on eternally "growing evidence," all of these deferrals of proof, allow the scientist to march boldly forward while treading the empty air. Worse, while we eagerly anticipate the final results, we forget to ask the most relevant questions about the real problem. The question should be this: *what is it about human beings that leads them to feel that the world into which they happen to have been born is inadequate to something they seem to feel they want* (both lack and desire)? And *why do the humans that feel this disappointment with things-as-they-are, this feeling of alienation, turn to art to both criticize the status quo and begin to suggest an alternative?* Those are the questions that need to be answered, but they won't be answered by science journalists like Lehrer, by mop makers, or even by neuroscientists, clever though they may be. They won't be answered because they have no interest in even asking the question. But not to ask this question is to indulge in a

self-satisfied thoughtlessness that is the public face of science today.

The thing that I find most inscrutable about all of the recent books and essays that have sought to give mechanistic explanations for consciousness, personality, emotions, creativity, the whole human sensorium, is how *happy* the authors seem about it. They're nearly giddy with the excitement, and so, for some reason, are many of their readers.

But for me, as Dylan sang, they're just "selling postcards of the hanging."

As you might expect, Lehrer's pop-science has its academic equivalents, like Antonio Damasio's Brain and Creativity Institute at the University of Southern California. Damasio has also written several books on the subject of consciousness and creativity, most recently *Self Comes to Mind* (2011).

Damasio's definition of consciousness is different from that of most Anglo-American researchers. Anglo-American neuroscientists have a very reductive definition: consciousness is the opposite of being unconscious or asleep. On the other hand, Damasio's definition is more far-reaching, more European in a sense, and worth remembering: "a state of mind in

which there is knowledge of one's own existence and the existence of surroundings." (167)

The way in which continental philosophy and Anglo-American materialism unite in Damasio's scheme is, if somewhat technical, also very revealing. Damasio's determination is to show how consciousness is possible because of the body ("the body is a foundation of the conscious mind"). But he sets out to demonstrate this conclusion in a manner reminiscent of phenomenology; he presents a logical "framework" displaying how the "self comes to mind." The framework, tracing an evolutionary path, looks something like the following: first there is mere body, or brain, followed by succeeding layers of gradually increasing complexity of neural networks across "hierarchies." Thus, from rudimentary brain function to the highest brain function:

Brain (the presence of a brain-like neural structure in a creature; even worms have these) →

Mind (a brain capable of body and environment "mapping"; humans and other sentient creatures have this) →

A Protoself of primordial feelings (pleasure/pain, located in the upper brain stem) →

A "core" self of the "here and now" (it is "about personhood but not necessarily identity") →

The Self (or "autobiographical" self, a "protago-nist"; in other words, the "I")* ➔

Finally, the human self as it functions socially (es-pecially through an engagement with language).

Like phenomenologists such as Edmund Husserl, Damasio wants to establish the Self as a freestanding presence, but, like a neuroscientist, he also wants the Self to be dependent upon an arrangement of matter. The trouble is that his first-this-then-this approach is as much about storytelling as it is about science. ("In the beginning there was the brain, a bit of neural mat-ter, then one day it discovered it had a mind. Finally, when it had grown up, it had a self, a real somebody.")

*Very strangely, Damasio states that other species also have this "autobiographical" self. He writes, "Most species whose brains gen-erate a self do so at a core level. Humans have both core self and autobiographical self. A number of mammals are likely to have both as well, namely wolves, our ape cousins, marine mammals and elephants, cats, and, of course, that off-the-scale species called the domestic dog." (27) Autobiographical? Do these bright beasts actually write their autobiographies themselves, or dictate into a speech recognition program? I can see it now: "Fetching the Paper: A Dog's Life in the Suburbs." For my own part, I'm reminded of Kafka's superb short story "A Report to an Academy" in which the speaker begins by saying, "You have done me the honor of invit-ing me to give your Academy an account of the life I formerly led as an ape." The reformed ape tells of being shot by his captors and shipped from Africa to Europe. During this trip he claims that he ceased being an ape and "I came to myself," thus anticipating—and just as plausibly—Damasio's story of how "self comes to mind."

To create this narrative framework, Damasio must structure distinctions that are finally without differences. Is there ever really a human mind that is not already inhabited by a self? Is there really a difference between "personhood" and "identity"? Is there ever a self that is not already contaminated by language and social symbols? And, of course, lost in all of this is any possibility that, as Buddhism argues, this entire self-making process is a *delusion*, and that its frantic, virus-like pursuit of its own reproduction, survival, success, or pure vain-glory is the cause of most of the world's suffering.

And where is language in all this? By Damasio's reading of the biology, language "emerged" after a "robust self" was already on the scene, so it is in the very last and most complex level of brain development. (306) He even goes so far as to say that "only after those brains developed language did it become widely known that minds did exist." (18) There is something clumsy and unintentionally comical about Damasio's phrasing. "Widely known"? To whom? He makes it sound as if there were already minds that could be informed that, "Headline: the brain has created language and language says minds exist." This is the kind of tail chasing that occurs often in Damasio's book, mostly because the paradoxes integral to the

problem don't easily tolerate imposed hierarchies and linear time schemes. It is like trying to consider the origin of language, or, of course, the famous chicken and its egg, only in this case there are eggs within eggs (like a Russian nested doll) and a proto-chicken for good measure.

Unfortunately, Damasio really does mean something close to the above. He thinks that there is a self that is somehow "robust" prior to the appearance of language. But how does this robust self become autobiographical before it has language? How does it narrate its "protagonist" function? For the post-Freudian theories of the psychologist Jacques Lacan, the "I" never emerges at all, robust or feeble, except by seeing itself in a world that is already symbolically structured. In what Lacan calls the Mirror Stage, the infant, the "little man," says, "I am *that*." And the *that* is the world into which it just happens to have been born. Thus are we "born in the USA," or given over to *sharia* law. As the Marxist Lacanian Louis Althusser put it, we are "hailed" by our culture, as if someone were calling to us from across a street. When we respond to that call, we become a subject to that culture (in Althusser's lingo, we are "interpolated").

In short, there is no possibility of a self in the absence of an already articulated symbolic world, and

yet we cannot know a time when a self or group of selves first created the symbolic order, not even in the caves of Altamira, for in order to create those paintings they must already have been members of a symbolic order. The matter is strictly, in Jacques Derrida's stern term, "undecidable."*

But, of course, as far as Damasio is concerned, thinkers like Lacan or Derrida or even old Kant can be safely sequestered among dead things or in Richard Dawkins's dismissible world of French phonyism. But that is a red herring. Just as it has been since the 19th century, the real problem is that the empiricists have no tolerance for what they're thinking on the continent, especially in Germany (for, in truth, the French poststructuralists were doing *German* philosophy). And the popular media shares this disdain because finally the popular media is empiricist in its

*Or, to use Kant's term, it is an "antinomy": a contradiction that goes beyond our ability to establish rational truth because it goes beyond possible experience. In this case, one cannot experience whether the symbols are a product of the self, or the self a product of symbols. In this way Kant put limits on the ambitions of reason, something that neuroscientists like Damasio are reluctant to accept.

You might be interested to know that the Buddha, too, refused to answer questions about origins, calling them "unindicated views," and commenting that such questions were "a jungle, a wilderness, a puppet-show, a writhing, and a fetter, and coupled with misery, ruin, despair, and agony."

assumptions. Like the Monty Python knight that says "ni," we are the people who take impressions, give them labels, organize the labels, and say "truth."

In spite of all these problems and reasons for skepticism, the truths provided by popular science, like caissons, go rolling along *as social directives*. The fine points may need to be worked out, the metaphysics as well, but that does not mean these truths shouldn't be applied in the here and now to the way we live. As Morse Peckham observes, "Such a word as 'truth' indicates that if an utterance is said to be 'true,' that statement amounts to a recommendation that the utterance in question be used as a control over behavior." (*Ideology*, xiii)*

If we are people who are subject to the authority of science, technology, and socio-economic bureaucracies, we are pointedly *not* people who wander, who play, tell stories, and, in general, indulge in the random. As Nietzsche argued in *The Birth of Tragedy*, the

*My favorite *reductio ad absurdum* example of science's social authority at work is an old TV commercial for puncture-proof tires. While a van drives up a highway, men toss every manner of metal junk out on the road behind them while a car plows through the wreckage without getting a flat. The men in the back of the van wear the iconographically-correct white lab coat of the scientist, as if to say "science vouches for these tires, therefore you ought to buy them." I'll bet we did, too.

difference between rational (and finite) truth-telling and playful (and infinite) fiction-making is the difference between Apollo and Dionysus, and Western culture is ever weaker and more *false* because of the dominance of the Apollonian rationalist and the slow dying of the Dionysian free spirit. The resentment and sense of alienation that this domination created among the Romantics was the essence of their counterculture and every counterculture since. Byron to Baudelaire to Buñuel to Lennon, all great *laughers* at the overweening sobriety of the Apollonian, and all great advocates for alternative realities, for the transvaluation of values, and for the freedom *to interpret the world by another idea.*

Like Peckham's Romantic scientist, Nietzsche sought the counterculture of a Dionysian Apollo. Between the hippies and the anti-war movement, we had a version of Nietzsche's ideal culture in the '60s: reason was for taking apart the "great shining lies" of the government, hippy invention was for an alternative to those lies and that government. These were the tribes—Berkeley and San Francisco—that Allen Ginsberg famously gathered in Golden Gate Park for the Human Be-In and that Abbie Hoffman synthesized in himself.

Popular science books flood the market, but there is rarely room for a response from the more skeptical traditions of European philosophy (and even less room for our notorious mockers). For, no, that's too "difficult" for the public, or there's no market for it, or it's "academic." But if it were allowed, this tradition that moves from Kant to Derrida would challenge science's conclusions in really powerful and threatening ways: threatening to its authority, as well as to the legitimacy of the economic and political power it helps sustain.

From Derrida's point of view, if he may be allowed to have one, Damasio is just another "purveyor of truth." His "framework" attempts to structure differences that don't actually exist in order to persuade us that his truth claims are really "what is." But in fact the framework is only a "trace," something that can only vainly *promise* the eventual arrival of Truth without actually being it. The framework promises the arrival of His Majesty the Sovereign Self. The phenomenologist would leave it there, but that is not good enough for the neuroscientist. His majesty's throne is intricately inlayed with shiny networks of neurons laced together in a double helix of twining columns of math.

In the end, Damasio and neuroscience in general find what they are looking for: a machine of flesh (excuse me, of eukaryotic cells, each with its own little selfish gene determined to survive). As Damasio insists, "... mental activity is caused by the brain events that antecede it..." (16), and, in one over-the-top instance in which Damasio shows his true face, "Emotion programs incorporate all the components of the life-regulation machinery that came along in the history of evolution...." (118) Philosophers like Derrida are dismissed as phony not because they're wrong but because they offer a very direct critique of the delusions of scientists-turned-pop-philosophers, critiques for which science has no answer in its own mechanistic idiom and no answer in any other idiom either because ... *it has no other idiom*. It has burned all those bridges—back to philosophy, back to art—and is now intellectually landlocked.

Another academic, if weird, attempt to show that brain events cause all mental activity is Sebastian Seung's presentation—"I Am My Connectome"—at the 2010 TED global conference.* This condensed

*TED is a nonprofit devoted to "Ideas Worth Spreading." Founded in 1984 by billionaire architect Richard Saul Wurman, it seeks to

representation of the ideas in Seung's book, *Connectome: How the Brain's Wiring Makes Us Who We Are*, is a particularly revealing example of neuroscience's dependence on narrative and metaphor, and its unwillingness to look at obvious gaps in its logic.

The setting for Seung's talk is remarkable in itself. TED is, apparently, serious about bringing science to its audience in a way that is entertaining and artful. Seung appears, microphone lashed to the side of his face, against a brilliant, cloudy-blue background of large letters in relief, all mixed illegibly and punctuated by recessed boxes holding past technological creations such as an old telephone, a pile of scrolls,

bring together people from three worlds: Technology, Entertainment, and Design. The price tag for a seat at one of TED's confabs is $6,000. TED might as well be a PAC fundraiser, and in some ways it is. From its inception, Silicon Valley politics have not been all about freewheeling creativity and the making of a techno-counterculture by an army of stringy-haired geeks. Much of Silicon Valley's politics has been about hyper-rationality, radical individualism, and the personal right to wealth and power. In other words, Ayn Rand. For example, Larry Ellison (Oracle), T. J. Rogers (Cypress Semiconductors), and John McCaskey are all acknowledged Randians. When Nick Hanauer, a Seattle venture capitalist, suggested in a TED talk that wealthy investors don't create jobs and that a tax on the rich is just what our sputtering economy needs, TED decided not to add the talk to its line of web lectures. As Chris Lehmann comments, Gilded Silicon Valley will never "say a disparaging word about wealth inequality." ("The Class That Dare Not Speak its Name," *In These Times*, July 2012)

a microphone, what appears to be a kitchen faucet, and, on the ground... a cage with pigeons sitting on it? (It's not easy to see what these things are, and certainly not easy to know what their visual rhetoric seeks to express.)

Seung comes out dressed in black, the collar of his shirt open, a rock star, the Jim Morrison of scientists. He seems to grin ironically at his audience, as if he knows that they know this will be as much spectacle as sober scientific investigation. He's part scientist, part televangelist, and part game-show host.

Seung begins by appealing to his audience's healthy skepticism about the idea that humans can be reduced to their chemistry. He offers:

> I would like to think that I am more than my genes. What do you guys think? Are you more than your genes? (Audience: Yes.) Yes? I think some people agree with me. I think we should make a statement. I think we should say it all together. All right: I'm more than my genes—altogether. Everybody: I am more than my genes. (Cheering.)

Well then, what are we? We are, Seung announces, our "connectome" (pronounced con-néc-tome, not

connect-to-me, or I-am-my-neurological-connec-
tions, although that meaning is strongly implied).
And what is a connectome?

> Since the 19th century, neuroscientists have
> speculated that maybe your memories—the
> information that makes you, you—maybe
> your memories are stored in the connections
> between your brain's neurons. And perhaps
> other aspects of your personal identity—
> maybe your personality and your intellect—
> maybe they're also encoded in the connections
> between your neurons.*

Seung explains that he doesn't know if this theory of
the connectome is true, but he does know that sci-
ence needs "more powerful technologies" to map all
of those neurons and their synapses.

Now, I hope you're wondering, how is this an im-
provement over thinking that you are your genome?
Seung seems to be using a sleight of hand to suggest
to his audience that he is not one of those godless

*Okay, wait a minute. Memories make you you, but then your
personality and your intellect—what do these words even mean?—
might be there too? So the you that is made by your memories is
lacking a personality? And an intellect? Those are add-ons?

Professor Seung

mechanical materialists, maybe he's a bit of a human-
ist, a real softy, only to turn around and say that hu-
mans are mechanical in a different way. But nowhere
does he explain why "I am my connectome" should
make anyone feel better about themselves than "I am
my genome."

But hold on, Seung warns, the connectome is
"not the whole story."

> ... there is a lot of evidence that neural activ-
> ity is encoding our thoughts, feelings and per-
> ceptions, our mental experiences. And there's
> a lot of evidence that neural activity can cause
> your connections to change. And if you put

those two facts together, it means that your experiences can change your connectome.... The connectome is where nature meets nurture.

The assumptions are thick here. The brain "encodes" our thoughts? And then, from the previous quote, "stores" them? These are metaphors, and the leading assumption these metaphors express is that it's okay to think of yourself as a complicated machine, in other words, a computer. At one point in the presentation Seung illustrates the complexity of neurology by showing his audience a vast wall of computers, hirsute with wiring. We are "soft machines," as William Burroughs put it.

Next, Seung blithely assumes that we all know what an "experience" is. What does he mean by the word? Is it the traditional passive reception of the Lockean empiricist? Is it those events that are set off by our will, our choosing to take piano lessons (Seung's example), which choice sets off a frenzy of rewiring as we learn "Für Elise"? Or is experience simply exposure from birth to a given culture and the way that culture teaches its residents to process each other's behavior? One way or another, the idea of experience is a long-bedeviled area of philosophical inquiry—inaugurated

by Aristotle's *tabula rasa*, Locke's "blank slate," Kant's "sensuous intuition," and the more self-reflective theories of idealism and phenomenology—and it is central to Seung's argument, although he seems not to know it. In Seung's rhetoric, "experience" is simply a cliché. After all, everyone knows what experience is, right?

What Seung doesn't want to acknowledge is that the whole project is dependent upon an experience-thing, something neither he nor neuroscience in general has anything to say about, but without which we have in the neurological system only a very sophisticated, very expensive plate of spaghetti. What he is ignoring is that this we-know-not-what thing called experience is simply an old mystery: consciousness. Consciousness is the ghost in Seung's machine, but he appears not to believe in ghosts. Instead, he coyly implies that all those dazzling colored lights coming out of brain scans are both cause and effect, a sort of mental perpetual motion machine, almost God . . . or the Wizard of Oz.

Science assures us that consciousness, like the origin of being itself, is something it is deeply interested in and that it will provide an explanation for eventually. But that is false. They are not interested in it because it would require them to be interested

in something beyond matter and math. What they are interested in is reducing both humans and the cosmos they inhabit to a machine and taking us—the audience that cheers, laughs, and says, "Yes!"—along for the ride.

This is not just a problem for knowledge; it is most importantly a problem for how we live. That is to say that the social effect of the kind of science I have been looking at—whether it be Big Science, popular science, scientism, or a blend of the three—is to create ideology. An ideology is a claim repeated again and again within a culture until it seems to attain the status of nature, and of course what is "natural" should be obeyed. "Science is beautiful," we're told. "All should be ordered according to Reason." "Work makes you creative." The ideology of science insists that we are not "free"; we are chemical expressions of our DNA and our neurons. We cannot will anything because our brains do our acting for us. We are like computers, or systems, and so is nature. Therefore, no one should be surprised if our lives are systematized.

Of course, we enter these systems at a very young age. There is: The education system, especially now that many cities, like Chicago, are perilously close to

simply handing education over to "charter schools" and the corporate class. The university system where we are told to "pick a major," which really means, if you want to pay off that student loan, find a job. The factory system (what's left of it). The corporate system with its honeycomb world of carrels, fit places for data drones. And even the wonderful new world of the high-tech creative economy, where all of the exciting jobs are to be found, and where the young and weird are milked of their weirdness. When we accept the naturalness of neuroscience's specious discoveries, and when we accept the world it helps to provide intellectual cover for, we become mere functions within systems.

In other words, and *nota bene* here, scientism's primary social effect is to make us feel at home within what Schiller called the "misery of culture," that distorted moment in which humanity is "nothing but a fragment." The social sin of the science that I have examined is that it tends to frustrate Schiller's dialectic and leave it immobilized in this misery. It is the same old story, and Schiller told it perfectly: "The concrete life of the individual is destroyed in order that the abstract idea of the whole may drag out its sorry existence."

•　　•　　•

In the second installment of Adam Curtis's powerful BBC documentary "All Watched Over By Machines of Loving Grace" (2010) he concludes, "This is the story of how our modern scientific idea of nature, the self-regulating ecosystem, is actually a machine fantasy. It has little to do with the real complexity of nature. It is based on cybernetic ideas that were projected on to nature in the 1950s by ambitious scientists. A static machine theory of order that sees humans, and everything else on the planet, as components—cogs—in a system."

A documentary like Curtis's tries to unsay the instructions of scientism. Unlike books by writers like Lehrer or Seung, the film does not merely repeat what the culture finds convenient to believe. Therefore, it is most unlikely that it will be echoed by the media in the way Lehrer's book or the works of popular science routinely are. The mass media recognizes in someone like Lehrer what it already thinks it thinks. Unfortunately for them, in Lehrer's instance it recognized a liar, which may be closer to the general truth than they know (i.e. what they think they think is also a lie). But for Adam Curtis, in spite of his relationship with the BBC, he can hope for little more than cult status, especially in the United States. It is as if Curtis calls to our culture from across a street; if the culture

echos his call, it risks undoing itself. In the end, the only possible response for American culture is strategic deafness and blindness: we don't see you, we don't hear you.

Or it's like the story attributed to William Vollmann. Suffering from a wrist injury so that he cannot type, his parents buy him a speech recognition program. He sits down to dictate a thank you note and says, "Dear Mom and Dad," which the program neatly translates as "this man is dead." Saying "unrecognizable" things to the culture gets much the same response: you're dead. Your perspective does not exist.

If refusal to recognize fails, if someone like Adam Curtis appeals to others so successfully that they begin to form a "mass" (a cohesive social movement), then the culture has no choice but to respond. But then it says, "We don't like you."

That's where the police come in.

V. WE INSIDERS

"There is a philosophy that says that if something is unobservable—unobservable in principle—it is not part of science. If there is no way to falsify or confirm a hypothesis, it belongs to the realm of metaphysical speculation, together with astrology and spiritualism. By that standard, most of the universe has no scientific reality—it's just a figment of our imaginations."

—Leonard Susskind

It was with some excitement that I came across an essay by Rebecca Newberger Goldstein, "The Hard Problem of Consciousness and the Solitude of the Poet." (*Tin House*, Vol. 13, No. 3) Goldstein—a novelist, philosopher, and science writer—has a problem with the mechanical materialism of neuroscience. She writes:

Sure, consciousness is a matter of matter—what else could it be, since that's what we *are*—but still, the fact that some hunks of matter have an inner life—is unlike any other properties of matter that we have yet encountered, much less accounted for. The laws of matter in motion can produce *this*, all *this*? Suddenly, matter wakes up and takes in the world? Suddenly, matter has an *attitude*, a *point of view, a fantasy life*?

She even lampoons the neuroscientist of the future who would account for a girl wounded in love by pointing to a group of neurons firing "over there."

Her first claim, a very good one, is that science is wrong to think that its mathematical modeling of matter in motion is adequate for all of nature. Her second claim is also promising: the language best suited for articulating the feeling of our "inner life," especially our feeling of solitude, is the language of literature and poetry. But there are problems, especially with the second part of her claim.

First, why does she tend to divvy up the world into those things that can be adequately described by mathematics and those that can't, as if science's sin is a kind of disciplinary overreaching? Is she trying to

recreate a version of Gould's "overlapping magisteria"? Science is for objective knowledge, and poetry (taking the place of religion) is for subjective feelings? The second problem I see is that she seems to think that what science misses has something to do with an "inner life," a place where young girls are wounded in love or feel lonely. She uses this term—inner life—repeatedly, but it is hopelessly vague. What does she mean by it? The language of the inner life doesn't sound to me so much like the work of poetry as it does the work of poetic cliché. You know: the students in creative writing who say that they want to "write about their feelings." Poetry may be the right place to look for an alternative to Seung's mechanisms, but probably not in the way that Goldstein presents it.

Among brain researchers, the problem that Goldstein is concerned with is known as the "qualia problem": why should neural events "feel" like anything at all? Why should looking at a "magnificent" seascape sunset be more than the simple registering of the visual fact? Where does the feeling of magnificence come from? Neuroscientists like Damasio try to explain this in terms of the coordination of parts of the brain, even while allowing for something "mysterious." But, we ought to ask, if Goldstein is right and poetry is the better way to account for this feeling,

why is that? Neither Damasio nor Goldstein are able to suggest what would have been commonplace for the poets and philosophers of the Romantic tradition: poetry is the most sensitive aspect of the symbolic order because it is the "softest"; like memory wax, it can shape itself to any impression; and it can do that because its language is the least tied to a specific meaning or reference. Words in poetry can come to mean whatever the poem needs them to mean. In this way, actually, the language of poetry is most characteristic of language as such. As Shelley writes in "A Defence of Poetry," "language itself is poetry."

> . . . we want the poetry of life; our calculations have outrun conception; we have eaten more than we can digest. The cultivation of those sciences which have enlarged the limits of the empire of man over the external world, has, for want of the poetical faculty, proportionally circumscribed those of the internal world; and man, having enslaved the elements, remains himself a slave. (1084)

Dependent upon the language of math, science tends to suffer from a form of the "locked in" syndrome (bodily paralysis while mentally alert): it

can't get out of itself and, from what I can tell, really doesn't much want to. It seems perfectly content in its self-referential world, never mind its tendency to enslave. It requires no impressions, especially if they must come from young girls disappointed in love.

What neuroscientists don't want to consider is the possibility that the "feelings" they fret over are not produced by brain parts but are, to one degree and another, the *creation of language itself.* As the narrator of Marcel Proust's *Swann's Way* observes, he could never go to a place if he hadn't read about it first. And of course the great romance of the novel is purely one of those French affairs where Swann "would never have fallen in love if he hadn't read about it first." Swann's feeling of love for Odette has little to do with Odette herself; rather, she is for him his private symbolic association of her with a painting by Botticelli and a phrase of music. Animals may have purely chemical or instinctual bonds with their mates, but that says almost nothing about the circus of desire and disappointment, pleasure and suffering, delusion and recognition that is romantic love. Virtually every novelist since Boccaccio has testified to this. (For a brilliant development of this idea, see Roland Barthes's *A Lover's Discourse* [1978].)

And this is obviously the case for the "beauties"

of an ocean sunset or a starry night. In the West, it wasn't until the eighteenth century that we began to imagine that nature is something worth looking at for itself, and not just as a background for Christian symbolism or the vain presentation of the cultivated estates of the nobility. As John Ruskin wrote, landscape painting was the "chief artistic creation of the nineteenth century," invented by painters like Claude Lorraine, John Constable, and Samuel Palmer. Such painting has taught us how to look at nature. Prior to this, for the ordinary person looking at the sea, it was as likely to evoke fear as aesthetic pleasure. After all, the sea was for many centuries the place where husbands went to die, leaving behind their disconsolate wives to pace on the widow's walk, the smell of dead herring in the air.

Another frustration here is that Goldstein is a philosopher, someone who has written a book about Spinoza. Well, she must know the tradition of German Idealism, and if she knows anything about Idealism she knows that, according to Friedrich Schelling, the only problem for philosophy was: "how are object (the world) and subject (our 'inner life,' as Goldstein has it) reconciled as reality or knowledge?" Shouldn't

that work be relevant to her concerns? Shouldn't that be a serious alternative to her science/poetry dualism?

Why is it that Idealism's forceful, thorough, and far-reaching critique of empiricism and mechanical materialism is almost never acknowledged or found useful by anybody, not contemporary philosophers, not theologians, and certainly not scientists? Is it just lost in a sort of cultural amnesia, forgotten ideas that if rediscovered would be joyfully met? Or is it something more malicious than that, a deliberate forgetting of the sort that we see when the victor gets to write the history books?

I think it is the latter. The victor, in this case, is the scientific worldview, but also that form of philosophical inquiry that has dominated in England and the United States since early in the twentieth century, logical positivism and analytic philosophy.* When Goldstein complains that the physicist's mathematics are not adequate to all of reality, she fails to mention that this same mathematical hubris long ago took over her own field, philosophy, beginning with Whitehead, Frege, Wittgenstein, and Russell. Analytic philosophy condemned all continental philosophy, what it called

*Logical positivism condemned metaphysics not as wrong but as having no meaning. They thought that all knowledge could be codified through a single standard language of science.

metaphysics, to the rubbish heap. As Bertrand Russell observed dismissively, "Hegel's philosophy is so odd that no one would have expected him to be able to get sane men to accept it, but he did. He set it out with so much obscurity that people thought it must be profound." In dismissing post-Kantian German philosophy, Russell prepared the way for the supremacy of mathematics and logic, rejoining the tradition coming out of Galileo that, as Goldstein points out, believed that the universe "is written in the language of mathematics."*

Goldstein concludes that the problem with the Galilean tradition is that it has a "tin ear" for some parts of reality, especially the dynamic subjective reality of human consciousness. That should mean, it would appear to me, that it is not only science but also contemporary philosophy that has this tin ear. You might, therefore, also think that she would see this as an opportunity to look at just what the logical positivists had rejected in 19th-century metaphysics. But she does not see the situation she describes as such an opportunity.

Instead, she turns to the contemporary philosopher

*Of course, old Hegel had his own attitude problems. Of the "scientific regime bequeathed by mathematics" he wrote, "Even if its unfitness is not clearly understood, little or no use is any longer made of it; and though not actually condemned outright, no one likes it very much."

Thomas Nagel's essay "What Is It Like to Be a Bat?" (1974). Her conclusion, following Nagel, is that there is something it is like to be a bat or a human, but that something is not math. For my pet parrots being a parrot is not like math, but then being a parrot for a parrot is not *like* anything. For a parrot, it's all about being what it is, something it is quite good at. Parrots don't do metaphor.*

The only creature that can say what it's like to be what it is can do so because it is the only creature that knows what "like" means, the only creature capable of seeing the similar in the dissimilar (the essence of genius for Aristotle): a human. In fact, the only creature—parrots included—that knows what it's like to be a parrot is a human, although our metaphors for parrot-ness are usually more charming than revealing. ("Coffee and oranges in a sunny chair, / and the green freedom of a cockatoo," writes Wallace Stevens in "Sunday Morning.") For that matter, humans also know what it's like to be a Minotaur, the original, discriminating buffalo-man. As for the parrot-in-itself, that essence is still exactly as Kant described it, the noumenal, the unknowable.

But for us humans, who do know about simile

*When I recently took the trouble to ask one of them—a small macaw—what she was like, she said, "Good girl." This led me to conclude that animals have no idea what they're really like.

and can try to say what it's like to be a human, what our similes say is, in the most ordinary sense ... metaphysics. Language, metaphor, map, and model, even scientific model, is what we have in the place of (and in a sense *beyond*) the Thing. Unfortunately, metaphysics is a word that Goldstein would rather avoid. (She is, after all, still a leading member of the academic philosophy community, and would like not to make too much of a spectacle of herself.) Nonetheless, 19th-century metaphysics was always a form of metaphor-making and storytelling, a fact brought home in Hans Vaihinger's seminal work *The Philosophy of As-If.* The later Wittgenstein of the *Philosophical Investigations* would come to similar conclusions. For Wittgenstein's famous fly in a bottle that wants to know what the bottle looks like, math is just one of many possible imaginary places from which it can get an outside perspective on its glassy universe. Math models reality with numbers just as the poet does with language. But then, of course, math *is* a language (unless you think that Newton didn't invent calculus but found it). Physics may be written in the language of mathematics, but it is a very different thing to say that nature is.

Let me emphasize this point. Physics is dependent upon mathematics, but mathematics is not

a science. Math's validity cannot be tested. In fact, mathematics has no relation to experience at all. This is an astonishing thing. E may equal MC^2, but that does not mean we know what E is. Gravity and electromagnetism are both forms of energy, but they have never been reconciled in a "unified field theory," mightily though Einstein and those who followed him have tried. As Richard Feynman acknowledges, "So we do not understand this energy as counting something at the moment, but just as a mathematical quantity, which is an abstract and rather peculiar circumstance." The situation remains peculiar. Feynman: "Why can we use mathematics to describe nature without a mechanism behind it? No one knows." (84)

In some ineffable sense, Newton both invented calculus *and* found it. (After all, Leibnitz developed calculus at about the same time, so perhaps it was there to be found, even if that only means there to be found in math's own historical tendency to ever greater abstraction.) But this is not a unique paradox; it describes our relation to everything. *The world is something that we both find and invent.* Artists, especially spiritually sensitive artists, are most concerned with this paradox. In the space between the symbol and the real is another kind of vibration that is perhaps both

different from and a lot like the jiggling of atoms. For the philosopher, the poet, and the composer, it is in that "space between" that they seek what, for lack of a better word, I'll call the divine. There the enormous complexity of the relation between symbol and world becomes very simple, and the polemics between their respective advocates vanish. As the French composer Olivier Messaien wrote of his masterpiece "Three Little Liturgies for the Divine Presence":

> The "Little Liturgies" require little comment.... I think that one must listen to my music, forgetting about its success ... and even forgetting about the music. What does a rose-window in a cathedral do? It teaches through image and symbol and all those figures that inhabit it—but what most catches the eye are those thousands of specks of color that ultimately resolve themselves into a single color that is quite obvious, so that someone looking on says only, "That window is blue" or "That window is violet."
>
> I had nothing more than this in mind....

For the scientist, blue is a particular wavelength in the light spectrum that is visible to humans. For

the linguist, blue is a sign or symbol carrying meaning (heaven, salvation, Caribbean vacation, etc.). But for an artist like Messaien, blue is a *presence*—both a thing and the experience of the thing—and only when we are attentive and responsive to this presence can we be said to understand it. As Messaien shows, attention requires a certain non-evaluative openness to the thing; to respond to what the openness offers is the act of music-making itself. It is as if Messaien were singing a duet with the world in which the vibration of the music and the vibration of the world (its jiggling atoms) sought mutual recognition. This, too, is something to which the scientist is, literally, "tone deaf."

The greatest problem with scientism—science's old faith in its jigsaw approach to reality—is that its conclusions about an objective world presuppose a presence—an experiencing thing—that it cannot bring itself to acknowledge. At best, it can try to *persuade* us that this subjective realm of experience is only another kind of object, a chemical machine called the brain whose "secrets" and "tricks" we are slowly discovering. All that we lack is "more powerful technologies" to make the discovery complete. But, for the

moment, and, as Sebastian Seung acknowledges, for the next century of research, we are offered only a promise of future certainty and a metaphor: we are *like* math, we are *like* machines, we are *like* computers. The superlative irony here is that to imagine we are machines means that we cannot be machines . . . because *machines don't imagine.*

As Seung displays in his presentation at TED, we are aggressively sold this vision, and, fatefully, to a large degree we believe it. But the dangers of agreeing with Seung go far beyond the possibility that he is wrong. Agreeing with him makes us all too accepting of the social consequences of his story: the human world as a *system.* If it needs to be said that we are not just systems, that we are also part of nature, that is only true insofar as nature, too, is a vast system, an ecosystem.

Beyond the book royalties and the opportunity for rock-star atmospherics, I don't know exactly why science feels any need to persuade us, the "general public," of anything. On the one hand, scientists feel no need to try to persuade us because *we're not scientists* and so cannot understand their mathematical proofs. On the other hand, when they do try to persuade us, as Seung does, they treat their audience like qualified idiots convinced by the most idiot-appropriate

metaphors. ("The brain is like a network of wires! And so are you!") The problem is that, from all appearances, *they have come to believe those metaphors themselves!* Unfortunately, they are quite incapable of providing an account of what metaphors are, how they work, why we need them, etc. So they end up with the brainiest math and technology inside a gunnysack of the ripest clichés. (As Seung says, "You're joining me on a quest, a voyage of discovery." While we're at it, we might as well boldly go where no man has gone before.)

Science too often forgets that its work is done in the analogue. As John Gribbin writes in a moment of clarity:

> As science (in particular, quantum theory) developed in the twentieth century it became increasingly clear that the images and physical models that we use to try to picture what is going on on scales far beyond the reach of our senses are no more than crutches to our imagination, and that we can only say that in certain circumstances a particular phenomenon behaves "as if" it were, say, a vibrating string, not that it *is* a vibrating string (or whatever).... Another analogy, also drawing

on twentieth-century science, may help to make the point. I am sometimes asked if I believe that there "really was" a Big Bang. The best answer is that the evidence we have is consistent with the idea that the Universe as we see it today has evolved from a hot, dense state (the Big Bang) about 13 billion years ago. In that sense, I believe there was a Big Bang. But this is not the same kind of belief as, for example, my belief that there is a large monument to Horatio Nelson in Trafalgar Square. (430)

Of course, a poet might want to suggest that even the statue of Nelson is a sort of shared symbolic hallucination, a "pediment of appearance," as Stevens put it, and not a reassuring datum. In fact, as Rilke wrote in "Archaic Torso of Apollo," the statue is not even a statue until it is "suffused with brilliance from inside." But, for the moment, the poet can take some satisfaction in Gribbin's honest acknowledgment.

But for scientists of Seung's ilk, science only finds what it is looking for. It expects subjectivity to be mechanical and material, so that's what it looks for and that's what it finds.

• • •

The important thing to remember, though few of us do, is that there are other metaphors than those offered to us by science, and other ways of thinking about what it's like to be a human. There is a long, now dishonored tradition in philosophy and the arts that seeks to account for the "interior distance," our personal and species internal landscape. The crucial thing to say is that this tradition is under no illusions that it is providing the Truth, the human-in-itself. It knows that it has nothing more to offer than its metaphors and stories, but what it will contend is that its metaphors will *feel* more familiar, more intuitively proximate, more *satisfying* than the disingenuous proposition that we're "products," or chemical machines, or three pounds of evolved flesh. What's more, these metaphors will also provide insight into something science is mostly clueless about: how we ought to live.

The Tibetan word for Buddhist means "insider." The West has its own tradition of inside-ism called Idealism. This tradition begins with Plato, Plotinus, the Gnostics, the neo-Platonists, and St. Augustine before exploding a thousand and more years later with rich, varied, and enduring force in the work of Kant, German Idealism, and Romanticism. Kant's Copernican Revolution argued that the world of

things-in-themselves was unknowable, and that the only things we can know are those mental processes— "categories" of the Understanding—that make experience possible at all.

For my purposes, the most important of the post-Kantian philosophers is Friedrich Schelling. Schelling was a friend to Hegel and the Schlegel brothers (creators and intellectual entrepreneurs of Romanticism); he was in the thick of the rich metaphysical and artistic developments in Germany in the late 1790s. The work that made him famous (as a young man of twenty-five) was *The System of Transcendental Idealism* (1800).

The *System* is by no means an easy book to read, both because of its specialized jargon (with the exception of the lyrical Schopenhauer, the Germans were all guilty of writing as if they feared to be understood), and because Schelling seems incapable of presenting his ideas consistently. For good reasons. The *System* has the feel of a book trying to discover what it really thinks (always the best kind of book). But a "system" it is not, in spite of its title. Schelling's strategy seems to be to surround his subject, trying first one way of looking at it, then another, and yet another. But for the intrepid there is something here, something superior to the idea that we are merely a tumble of

chemicals and tissues, and something that has the feel of a human inner life, with its nuanced sensorium, its fearful capacity to act and will, and its psychologically fragile relation—thanks to boredom, despair, existential anomie, general hopelessness, etc.— to "Me."

For the philosophy of Schelling and Schopenhauer, the poetry of Hölderlin and Novalis, and the existential philosophy of Nietzsche that will in due course follow, the self is always also the burden of a self that is full of delusions, uncertainties, guilt, and suffering. This self is not confidently grounded in a pasta primavera of neurons.

No.

This self doesn't know that it is its neurons because it doesn't know what it is at all. Worse yet, even when it does have some inkling of what it is, it often doesn't like what it discerns, and sinks into a feeling of guilt for the sin of being anything whatsoever. Science tries to tell us how the brain composes itself, and how it thinks, but not how and why it suffers as a direct consequence of its thinking. (The brains depicted by Lehrer, Damasio, and Seung seem such cheerful, bourgeois brains.) Why does saying "I am" lead to asking "but what am I?" and why does that question seem so often to hurt? As Vanya put it in Chekhov's *Uncle Vanya*:

Oh my god, I'm forty-seven. Suppose I live to
be sixty, that means I have still thirteen years
to go. It's too long. How am I to get through
those thirteen years? What am I to do? How
do I fill the time? Oh, can you think—? (160)

Is this existential angst really only about neurotrans-
mitters or low inventories of serotonin and dopamine?
Is this Uncle Vanya's connectome talking smack? Is
Chekhov only making chemistry dramatic? No, this
is the pain of an animal torn between biology and
the symbolic. Only immersion in the symbolic—in
"meaning"—will lead an animal to worry that it's go-
ing to live too long.

Neuroscientists seem determined not to notice
this aspect of the human condition, and so they can
offer no solace to the Uncle Vanyas of the world. Un-
til very recently, it has been the job of art and philoso-
phy to notice this pain and offer its "consolations," as
Boethius put it. Let's consider what Schelling has to
offer and see if we don't prefer it to the light shed by
the un-shaded bulb of the sciences.

Schelling's philosophy proceeds from a critique of

empiricism/objectivism. It's a very simple criticism, really, and takes little more than a sentence to make, but it is as relevant today as it was in his time. Schelling argues that empiricism is flawed from the beginning because it fails to take seriously the fact that the things it observes require an observer. The tree may be out there, but it doesn't present itself as biological organism or as math. For that it needs assistance. Unfortunately, science takes this math-making observer to be self-evident and requiring no theoretical explanation. As Schelling writes, "Empiricism has no trouble in explaining impressions, since it completely overlooks the fact that the self ... must already be active." (65) So, for example, Sebastian Seung may write a book claiming that we are our "wiring," but the book itself and Seung himself do not feel like wiring. The book feels *intended*, the product of its creators *will*. This may be an illusion, but it is not an illusion that can be explained by wiring. The biologist J. B. S. Haldane put it in very similar terms: "It seems to me immensely unlikely that mind is a mere by-product of matter. For if my mental processes are determined wholly by the motions of atoms in my brain I have no reason to suppose that my beliefs are true." (209)

In short, our perceptions and interpretations of

the world are always far more complicated than mere physical impressions can explain. The self that takes the impression must already be active constituting itself before sensation is even possible. The self is something more than Plato's wax tablet; it must play a productive role in the life of the object.

> For the dogmatist [the scientist], bounded-ness [the objective world that sets limits on the self] comes first, and self-consciousness second. This is unthinkable. (43)

This is precisely what I described as missing in Seung's logic. Here he is describing this connectome that "makes us who we are," but the whole time there's this other thing, "experience," that is essential to but different from the activities of the connectome. This, too, is "unthinkable," although that fact doesn't stop Seung from trying. He's wrong for reasons Schelling made clear long ago.

Empiricism has a "basic prejudice": "that there are things outside us." But this is only true if we presuppose that "I exist" as a repository of impressions of those outside things. But what does it mean for an "I" to exist? This powerful criticism allows Schelling

to recast the purpose of philosophy. Philosophy has but one task: to explain "how our presentations [experiences] can absolutely coincide with objects existing wholly independent of them." (10) As he pithily puts it, "How does intelligence come to be added to nature?"

What Schelling seeks to describe is neither realism nor idealism but an ideal-realism. (Remember Morse Peckham's "Romantic science.") He wants, just as we all should want, to understand how the conscious (human) and the unconscious (world) come to concurrence, that is to say, come to life and knowledge. His is both a transcendental and a natural philosophy.

Criticism of empirical dogmatism in place, Schelling must next *show* how intelligence comes to be added to nature. To do this, he feels required to use a temporal schema that he describes variously as "moments," as a "graduated sequence," as a "progressive history," a continuum, a series of activities, and, most grandly, as three "epochs." Philosophy is this only: *the "free recapitulation of the original series of acts" that serve to make the self and its world.* As with Hegel (who took the idea from Schelling), the development of consciousness is temporal and progressive. If you will,

it is *evolutionary*.* I will grossly simplify Schelling's description of this progressive development by saying that there is first a moment of the Ideal, then a moment of the Real, and finally the moment of the Transcendent. (*Nota bene*: although he presents these moments in a sort of chronology, it would be an error to think that they came about in any order. This "development" is a device for unpacking something that is actually a unity.)

The Ideal: the self becomes active in seeing itself for the first time as an object. We call this self/object self-consciousness. The self becomes an object to itself.

But what is this thing that says, "I am"? Surely it is not the "I am" itself; if it were, we would be trapped in an infinite regression of "I's" that say "I am." Schelling deduces from this fact the necessity of

*Is Darwin's evolutionary "descent" even thinkable without the Idealist's "dialectic"? For that matter, is quantum physics thinkable without Idealism? As Sir Arthur Eddington, the famous British astrophysicist of the early 20th century, wrote: "The stuff of the world is mind-stuff." His compatriot, physicist Sir James Jeans, wrote, "I incline to the idealistic theory that consciousness is fundamental, and that the material universe is derivative from consciousness, not consciousness from the material universe... In general the universe seems to me to be nearer to a great thought than to a great machine."
Romantics.

a *logically* prior "Self" that we might call consciousness as such, an intuition of a common mind that not only binds together the world of the present but binds us to every past world. And what provides this world-subjectivity? Or, as we more commonly wonder, what is it that I share with others that makes us all human and deserving of mutual respect? Schelling calls whatever-this-is the "Absolute Self."

Schelling:

> Everyone can regard himself as the object of these investigations. But to explain himself to himself, he must first have suspended all individuality within himself, for it is precisely this which is to be explained. If all the bounds of individual individuality are removed, nothing remains behind save the absolute intelligence. If the bounds of intelligence are also once more suspended, nothing remains but the absolute self. (116)

What causes or creates this original Self that restores itself over time in a lot of individual, limited selves? Nothing, or nothing knowable. The fact of consciousness is not a result, and its causes will not be found no matter how many expensive, super-humanly

powerful technologies Sebastian Seung and his collaborators bring to bear. It is, in philosophical parlance, "unconditioned." My perception simply is. There is no possibility of explaining it as something produced. There is no possibility for evidence of the origin of perception; it is a necessary postulate. It is a given.

> Since the ground of the limit [the point of engagement between self and thing] lies neither in self nor thing, it lies nowhere; it exists absolutely because it exists and is as it is because that is how it is. (71)

Or as Johann Fichte, Schelling's mentor, puts it in his *The Vocation of Man*:

> Of course, I cannot explain how the force of nature produces thought. But, then, can I explain any better how it produces the formation of a plant, the movement of an animal? I am, of course, not going to lapse into the perverse enterprise of deriving thought from a mere arrangement of matter. . . . Those original forces of nature are not to be explained at all, nor can they be explained, for everything explainable is to be explained by them. There

just happens to be thought, it simply is, just as the formative force of nature just happens to be and simply is. (11–12)

Since, so far as I know, we are still convinced of the fact of consciousness, "hard problem" though it is, and since we are no closer to knowing what it is than were Schelling and Fichte, I would say that what they describe is the real state of affairs. Also, note that this is not a theological argument. Schelling is not suggesting that this is where God comes in, creator of consciousness. But he is saying that the unconditioned "I"—not you or me but consciousness as such—is the strongest possible limitation on what science may claim for its own activities.

Of course, this conclusion is what science wants to deny, mostly because it is ever vigilant against any form of spiritual or extra-material reality. Unfortunately, science's options are poor. It can deny that the problem is a real problem (Russell); or it can say that this is someone else's problem (the theologian's or the poet's—a very bad faith claim since it has no real respect for the work of theologians and poets); or it can say, as Seung does, that in time science will explain it all mechanically, but in the meantime you should just continue to think of the self as bio-mechanical.

Is Schelling's claim for a super-consciousness, or Absolute Self, strange, mystical, and outmoded? I don't think so. Jacob Bronowski's idea that there is an "ascent of man" is a very similar idea. Humankind's ascent is nothing that a single individual experiences or accomplishes. It is trans-historical and trans-human. And so the ascent happens not in a given consciousness but in a kind of super-consciousness—the "mind of man"—that is carried forward and recapitulated in multiple lives and multiple cultures over time. Its home is neither physical nor spiritual; its home is the *symbolic*. As Bronowski says in the last episode of his series, "The democracy of the intellect comes from printed books." But then Bronowski was a Romantic as well as a scientist.

Bronowski's friend and fellow scientist C. P. Snow was even more unabashed. At the end of his magisterial eleven-novel sequence, *Strangers and Brothers*, on the last page of the last book (*Last Things*), Snow abandons for a moment all partisan feelings for the scientific worldview. He is imagining the end of his character Lewis Eliot's life, the end of his own work as a novelist, and surely the end of his life as well. In this passage Eliot is projecting into the future a kind of continuation of his own humanity in his son, who has just struck off into the world to pursue his altruistic goals. Eliot gives us these last words:

Whether one liked it or not, one was propelled by a process of renewal, or hope, or will, that wasn't in the strictest sense one's own. That was as true, so far as I could judge first-hand, for the old as well as the young. It was as true of me as it was for Charles. Whether it was true of extreme old age I couldn't tell: but my guess was, that this particular repository of self, this "I" which felt and spoke for each of us, lived in a dimension of its own. (430)

In a much more American context, Schelling's intuition can be found in John Steinbeck's Tom Joad who, in his famous soliloquy, says:

Tom: Well, maybe like Casy says, a fella ain't got a soul of his own, but on'y a piece of a big one—an' then—
Ma: Then what, Tom?
Tom: Then it don' matter. Then I'll be all aroun' in the dark. I'll be ever'where—wherever you look.*

It is strange to see such similar expressions coming from such different sources, and of course they could

*Dialogue from the movie *The Grapes of Wrath*, directed by John Ford, 1940.

be multiplied endlessly. The explanation, for me, is that both Snow and Steinbeck are in their different ways children of Romanticism. Their courage, their resistance, their idealism are from that common source, history's ongoing second chapter, never mind that there is no scientific way of knowing that what they say is true.

The Real: here the self, already an object for itself, breaks beyond the limit of self-awareness in discovering a second limitation, or boundary, on its activities: the world of sensation and things. For this moment, the moment of empiricism, "the self is ignorant of the fact that this opposite is its own product." (69) That is, the self is ignorant of the fact that this vast concrete world is present only because of the activities of the self that gives to the world its form. Thomas Carlyle, the best German philosopher in 19th-century England, expressed this idea beautifully:

> [Man] everywhere finds himself encompassed with Symbols, recognised as such or not recognised: the Universe is but one vast Symbol of God. . . . Not a Hut he builds but is the visible embodiment of a Thought; but bears visible record of invisible things; but is, in the transcendental sense, symbolical as well as real. (152)

It is here that Schelling's realism is more realistic than the empiricist's. Unlike the scientist, Schelling does not separate the hard problem of the origin of consciousness from the equally hard problem of the origin of matter. For him, the two are aspects of the same problem. To think that the one problem has something to do with the Big Bang, the other something to do with the evolution of brain structure, and ne'er the twain shall meet, is simply to get it wrong from the very beginning.

The Transcendental: in this final stage the self becomes aware not only of itself and of a "limiting" world of objects outside of it (the not-me), it becomes aware that the opposition of self and world is really a union. The "I am" and the "it is" are both productions of the activities of Self and Being. Self and world are "reciprocally conditioned by each other." (67) The "thing itself" is but the shadow of ideal activity, but so is the "I am."

In this highest stage the self and its world are "simultaneously separated and gathered together." (69)

Is Schelling's philosophy difficult? Yes, I suppose so, although in my own experience the more familiar this way of thinking becomes the more obvious it starts to feel. As with Einstein's notion of spacetime, Schelling's

philosophy seems to violate ordinary human experience and intuition because it undoes something that feels very natural: the opposition between self and world, in short, Cartesian dualism. So, yes, I grant you, it's difficult. But is someone under the impression that modern physics is easy to understand? (I have yet to emerge from reading an account of how light is a function of electro-magnetic fields without feeling that I missed something.) And yet that difficulty is given every kind of opportunity to make its case to the public, including high-tech presentations to adoring audiences and best-selling books. But Schelling? "Too academic," whatever that means. If you ask me, it's just a way of burying him as though he were a vanquished foe, which is exactly what he is.

What's disturbing is what this all says about American culture. We are a culture in which self-evident lies, supported by stunning lapses in argument, are eagerly taken up by our most literate public, which is happy to call it "fascinating" and "provocative," while also assuming that it is our inevitable future. Good future? Bad future? Who cares, it's as inevitable as next year's smartphone apps. Meanwhile, a philosophy that takes every care not to leave little things like subjectivity and language out of its considerations is essentially banished from the field. Never mind that

Schelling's philosophy has a much better idea what it's "like" to be human, takes care to account for our interior distance, and does not contribute to a global social system that is "watched over by machines of loving grace." If I have to choose between Schelling and the blunt weapon called a brain scan, I'll take the German.

Unlike the arguments of neurophysicists, Schelling's philosophy is not limited to its own narrow discoveries but sheds light on ethics, politics, the rule of law, and art. Science cannot do this. Even if it showed how biomechanics generated consciousness and creativity, it would be no closer to understanding *why* we make art except, perhaps, to say that it offers an "evolutionary advantage" of some kind. But in the context created by a specific work of art in its full complexity—personal, formal, spiritual, and social—the Darwinian explanation is an exercise in self-ridicule. It doesn't solve the problem—"why art?" or, as they'd prefer, "why creativity?"—it explains it away.

For Schelling, art is not something pretty on the margins of human society (as it appears to be for Dawkins). Art is itself "theoretical"—it *thinks*. Philosophy can only express the transcendental synthesis

of self and world schematically, but art "achieves the impossible, namely to resolve an infinite opposition in a finite product." (230) Art is capable of *being* that transcendental synthesis. Schelling greatly enlarges the already large role of art as found in Schiller and Fichte, and in doing so makes possible Schopenhauer and Nietzsche, who will follow him. This is why for so many philosophers of the 19th century art, not math, was the supreme expression of philosophy. (That, I think, is a very usable shorthand for the difference between 19th- and 20th-century philosophy, or between Germany and England.) For Schopenhauer in particular, the closest we come to knowing the "inner life" of humans at home in the world of nature, the closest we come to knowing what it is like to be human-in-the-world, is music. As he writes in *The World as Will and Idea*, "Music is the unconscious exercise in metaphysics in which the mind does not know that it is philosophizing."

Schelling:

> Philosophy attains, indeed, to the highest, but it brings to this summit only, so to say, the fraction of a man. Art brings the whole man, as he is, to that point, namely to a knowledge of the highest... (233)

What fraction of a man does neuroscience bring us? A super-thin slice of brain tissue? A computer protocol? A promise of more later? For all his arrogant pride in what he can demonstrate, and the certain procedures that produce knowledge, the scientist is insensible to the nuance of what-it's-like to be human, while in art a harmonic shift, an unexpected rhythm, will seem to say so much and so convincingly. It gives us, "Yes, that is what it's like to feel that feeling," whether joy, rage, despair, heroic triumph, pensiveness, or whatever emotion or combination of emotions it may be.

No musician of Schelling's time was more conscious of the metaphysical properties of his music than Beethoven. The Introduction to the first movement of Beethoven's 9th Symphony, the first musical work ever to attempt to encompass our world in its totality—to go beyond the pleasurable confines of the court and into the musical presentation of terrors to be transcended within the work of art itself—begins with a primeval open fifth, A-E. The key is ambiguous because of the missing third. Suddenly, there is a change to another open fifth, D-A. At last, a triad and a home key is established with the introduction of an F: we are in D minor, and out of that comes the first theme. It is violent, tragic, describing a vicious reality.

The music returns briefly to the primeval introduction, this time clearly in D minor, which modulates to a restatement of the theme, but this time the theme is in Bb major, and although the four-note motive is the same, the feeling is very different: subjective, heroic, clearly in opposition to the first statement of theme one in D minor. This harmonic polarity, this statement of the objective real opposed by the subjective hero, will continue in various forms throughout the symphony until it is finally resolved in the last movement's choral glories and Schiller's "Ode to Joy." In other words, just as in Schelling, the war of subject and object ends in transcendence.*

As the Beethoven biographer Maynard Solomon writes of Beethoven's late fugues:

> The passage through the labyrinth, from darkness to light, from doubt to belief, from suffering to joy cannot be without its unique torments. By the same token, such an emergence is not without its manic raptures—the aspect that led [French novelist and critic Romaine] Rolland to stress the mood of turbulent

*I am indebted to Professor Robert Greenberg's splendid analysis of the 9th in his lectures for The Teaching Company titled *The Symphonies of Beethoven*.

caprice, the laughing spirit that erupts from
the fugal texture. (392)

The 9th symphony is a confirmation of Schelling's
confidence in the metaphysical capacity of art, a ca-
pacity that will be expanded by Wagner, Mahler, and
Schoenberg. But, as Solomon observes, it is not just
metaphysics. The music also has a strong social pur-
pose; in fact, this music is nothing without its social
purpose. Solomon is writing of the political realities
of Viennese life in the 1790s under the police state of
Emperor Franz I and Prince Metternich.

In a sense, we may view the masterpieces of
the high-Classic style as a music into which
flowed the thwarted impulses of the [Enlight-
enment], a music of meditative cast that re-
fuses to give way to superficiality and pretense,
a music that is "Classic" by virtue of its avoid-
ance of the extremes of triviality and grandios-
ity. At the same time, this music expressed a
utopian ideal: the creation of a self-contained
world symbolic of the higher values of ratio-
nality, play, and beauty. In the greater works of
Mozart, Haydn, and the early Beethoven are
condensed some of the contradictory feelings

of Viennese life. Gaiety is undermined by a sense of loss, courtly grace is penetrated by brusque and dissonant elements, and profound meditation is intermingled with fantasy.... Despite, or perhaps because of, his iconoclasm and rebelliousness, Vienna was to find in Beethoven its mythmaker, the creator of its new "sacred history," one who was prepared to furnish it with a model of heroism as well as beauty during an age of revolution and destruction and to hold out the image of an era of reconciliation and freedom to come. (125–6)

Can this be the same Beethoven whose creativity is like that of Procter & Gamble's mop makers?

It is a travesty to think so.

VI. IN PRAISE OF PLAY, DISSONANCE, AND FREAKING OUT

"Man is nature creatively looking back at itself."

—Friedrich Schlegel

For a Romantic, the most desirable society is not one organized for the benefit of the nobility, or the church, or capitalism, or even science and reason, but one that maximizes the tolerance for play. It is striking how often and how consistently the word "play" appears in Romantic philosophy, especially in Schiller (a human "may be said to be at play when the stimulus is sheer plenitude of vitality, when superabundance of life is its own incentive to action." [130]) and in Friedrich Schlegel's *Atheneum Fragments*, where he writes, "The Romantic kind of poetry is still in the state

of becoming; that, in fact, is its real essence: that it should forever be becoming and never be perfected." (249) The heroes of Romantic philosophy were not philosophers but poets and writers like Rabelais, Boccaccio, Shakespeare, Cervantes, and, especially, Laurence Sterne and his *Tristram Shandy*.*

The historical trail left by Romanticism moves through the Wagnerians, to the symbolists, to the avant-gardes of modernism, to the Beats, to psychedelia, right down to the incitements of indie music, urban hipsterism, and the playfully anarchic strategies of the Occupy movement. These are all "condensations," as Freud might say, of the Romantic spirit. What they all share is the conviction that the world and our place in it is a story-in-progress, and that culture is a matrix of contesting stories, just as our recent culture wars show. Of course, many of the combatants in these wars are not conscious of the fact that they're telling stories. Religious fundamentalism certainly

*Sterne's legacy is astonishing: Denis Diderot's *Jacques the Fatalist*, Schiller's "On Naïve and Sentimental Poetry," Goethe's *Wilhelm Meister's Travels*, Schlegel's *Atheneum Fragments*, Byron's *Don Juan*, Carlyle's *Sartor Resartus*, and in the twentieth century countless modernist/postmodern "experiments" such as Flann O'Brien's *At Swim-Two-Birds*. Of course, Sterne himself had a master: François Rabelais. Before Rabelais? He would appear to be one of those evolutionary gaps. He is a singularity, a Big Bang that says, "Drink!"

isn't, and neither is science. Romanticism's difference has always been that it is the one that *knows* human societies are largely a matter of willful storytellers. For that reason, it has taken a certain incorrigible pleasure, an anarchic joy, in providing alternative narratives, counter-narratives and thus counter-cultures. Its ethic of play is the ideology of anti-ideology; it is a kind of vandalism, slipping through the night with a can of spray paint in order to deface the monuments of order. As Peckham puts it, "A truth that is announced as a lie is a higher truth than a truth that is announced as a truth."

Romantics are happy to be willful arrangers, and tend to resent political administrations that limit their powers of arrangement and re-arrangement. They even have a name for their resentment: alienation. *Homo analogos* ought to be oriented toward the whole of existence, and so resents a condition in which employment or unemployment are the two poor possibilities in a world with no escape. *Homo analogos* hates servility, and yet we mostly do what we're told.

One of my favorite examples of what I'm describing is James Joyce's early collection of stories, *Dubliners*. In this work Joyce condemns all the social forces—church, family, work—that make people *dead in their*

lives (the story "The Dead" concludes the collection). All of the stories are fictional case studies of how the Irish fail, each one in his and her own pathetic way, but all ultimately undone by their own innocence, fecklessness, stupidity, or cowardice in the face of Dublin's great repressive institutions. But James Joyce, the Master Artificer standing coolly outside his creation, paring his nails, transcends Irish alienation and "becomes who he is"—the Artist as high priest to the Imagination—and *Dubliners* itself is the proof of Joyce's success. As with Nietzsche, there's something a little egoistic about Joyce's triumph, but the work continues to offer guidance to those who would be *alive*, who would be one of Nietzsche's free spirits.

Of course, science, too, can claim to liberate us from some of what Joyce and Nietzsche struggled against: the destructive authority of religion as well as the myths of family and state (not so much capitalism, with which science has been and remains all too comfy). But Romanticism goes science one better: it also liberates us from the scam—the *delusions*—of science, of technology, and of the reign of the ever more efficient administration of life that has been the essential human problem in the West for the last two centuries.

• • •

To return to the question with which I began this book, why does science call what it learns—through telescopes, fossils, or elegant equations—beautiful? Is there a sense in which it is correct? If we knew the answer to this question, would we know what the arts and sciences have (or ought to have) in common?

I will hazard an observation: when scientists get excited about a discovery, their excitement is mostly about the *dissonance* of their new knowledge. We thought the Earth was at the center of the universe, well, *see this*, we orbit around the sun. We thought that man was created in God's image, well, *see this*, the fossil. We thought that chemistry was a matter of substances, well, *see this*, the atom and its electrons. We thought gravity was exclusively a force, well, *see this*, the warp of spacetime. Science is beautiful when the confirmation of its theories *disconfirms* the dominant beliefs of the culture it is working within, or simply disconfirms the intuitions of the human brain itself. The "weird" science of the last century, weird even to scientists, is the most dissonant and counter-intuitive form of knowledge in human history. So weird is the physics of string theory that it seems to have gone beyond anything empirical. Of course, we will not know for some time if this theory is beautiful or merely a great folly, but even if it turns out to be folly

there is still something beautiful—and gloriously human—about the audacity of its vision.

The beauties of science are very durable. The Copernican revolution is *still* something that we are intuitively uncomfortable with. One asks, "I'm on a round ball in empty space, spinning and circling a big round burning thing? And this is all happening in a distant and undistinguished corner of a cosmos that has every appearance of being infinite?" To this day, for most people, to think such thoughts is to invite vertigo, but it is for us, now, a very pleasurable vertigo at which we can smile as if we were teenagers getting off a roller coaster. There is something pleasurable and happy-making about science's inexhaustible capacity to show that the most certain things are illusory. And much to its credit, most of the time those certain things that are undermined are the earlier certainties of science itself.

Unfortunately, not all of science's beauties look beautiful to everyone. Many of its dissonant discoveries have been met with hostility and skepticism by the general culture, especially by those whose social authority is threatened. Even science itself has and will continue to participate in this hostility in its ongoing internal "science wars," the Black Hole war between Stephen Hawking and Leonard Susskind being the

most recent. What science finds beautiful the culture often finds horrifying, or disturbing, or politically and economically inconvenient.

As for art, its history is nothing but its dissonances, especially since Romanticism. Most art innovations are, at first, accused of being impious, or treasonous, or ugly, or decadent, depending upon the ideology (Peckham's world of "regnant platitudes") that objects to it. Symbolism, Franz Liszt's *diabolus in musica* (the "devil's chord"), Impressionism, Surrealism, twelve-tone music, *Finnegans Wake*, abstract expressionism, Mapplethorpe's brutal yet elegant photographs, and of course rock 'n' roll from Elvis to punk and beyond, all of these artists and art forms thrived on dissonance of one sort or another. For the artist, that dissonance feels like life itself. It feels like play and it feels like *being alive*. I can't imagine that a scientist working on a new way of thinking about the physical world doesn't feel something very similar.

In short, science and art are at their best when they are, like nature, dynamic. When they seek finality, they are dead. Science fails when it insists too strongly upon Fact, Truth, Knowledge, or aligns itself with a social order that is fundamentally hostile to change and simply treats science as a pimp treats a whore (I'll

give you this grant, but you give me that missile).*Art fails when it denies discontinuity and innovation, and tries to return to "fundamentals" or "rules for proper making," thus descending to a less demanding and less threatening kind of art in which the rate of artistic dynamism is slowed. As we have seen in American literature since the 1980s, a retrograde realism has been strongly asserted against the dissonant playfulness of modern and postmodern fiction and poetry. That the cultural establishment has been happy with the stability that realism has provided is confirmed daily by critics like Michiko Kakutani in the *New York Times* when she finds every novelistic innovation to be "self-indulgent."

*An episode of the PBS program NOVA broadcast in January of 2013 outlined the history of the development of "flying robots," especially the Predator drone. Late in the program a research scientist working on autonomous drones (not requiring GPS) stated, "I'd like to see this technology used for humanitarian purposes [responding to 911 emergencies]. . . . But any technology that you develop there are always people that will use it in ways that the scientist never intended them to be used."

I don't know how scientists can think this while receiving grants from the DOD's DARPA (Defense Advanced Research Projects Agency). DARPA ("100 geniuses connected by a travel agent," as it describes itself) also provides funding for MAHEM (molten penetrating munitions), for the Human Universal Load Carrier (battery-powered human exoskeleton), and for remote-controlled insects (this category does not include earthworm-like robots).

Something very similar happened to cinema at about the same time. The wonders of the cinematic *auteurs* of the '50s and '60s (so-called "art house" movies) were overthrown in one notorious instant: the hyperbolic vilification of Michael Cimino's *Heaven's Gate* (1980). That single film codified the emerging consensus among critics and studios that the "narcissism" of the artist/director was much worse (and certainly less manageable and economically predictable) than the popular and accessible movies of the time like *Jaws* and *Star Wars*, movies that "everyone can enjoy." The film *The Big Chill* (1983) was the official announcement: the '60s are dead, now, let's make some money. Of course, Hollywood broke out in the accountant's dance of joy at this critical assessment. Ending art's rebellious romp with a renewed Romanticism (as in the work of that glorious man Federico Fellini) and making art measure its success or failure only in terms of its profitability was one of the most important ideological events of the 1980s (second only to Reagan's creation of that free-market fairy tale, "supply-side economics").

We Romantics, we Free Spirits (as Nietzsche liked to say), are in exile. But as with the Jews in Babylon there is a "faithful remnant." I hope that this book has

provided some small degree of self-knowledge for that remnant.

Part of that self-knowledge is this: when science and art are beautiful everybody "freaks out" (as Frank Zappa and the Mothers of Invention did) either in horror or joy.

AFTERWORD

The most unexpected criticism I received when *The Science Delusion* first appeared was that I hated science. I say this is strange because, for one, I make a considerable effort in the book's last chapter to describe the beauty of science. (It *was* in the last chapter, though, and perhaps the thinner-skinned didn't make it that far.) And from the introduction on, I insist repeatedly that my interest is not in science as such but in science as *ideology*, or "scientism."

Of course, all human cultures need ideology. In fact, culture *is* ideology, if by that term we mean the stories we tell ourselves and through which we learn to live. Culture is the product, in philosopher Paul Ricoeur's phrase, of the "social imagination." At their best, these stories are transparent without being capricious: we know at some level that they are stories, and yet they seem to us crucial to our sense of who we are. The stories about Jesus in the Gospels are probably the most familiar of these narratives in

the West. Whether believer or atheist, we think there is something noble in the idea of Jesus' benevolence (literally, "goodwill"). Even Nietzsche, that scourge of Christianity, thought that Jesus was "the most noble of men."

The problem—and the negative meaning of ideology—comes when a culture's ethical imagination is distorted through the work of a schism that wants to appear to be keeping faith with the narratives of the whole while really only being interested in the well-being of some small part of the culture. Ideology becomes a problem when it is only about self-interest. For example, we are in the presence of a noxious ideology when politicians like Rand Paul make the Randian argument that food stamps or extended unemployment benefits should be eliminated because those programs are an insult to the poor and not really compassionate at all. The unemployed need tougher love than food stamps can provide. And yet Paul would never acknowledge that his position is anything other than perfectly in keeping with what American ethics has always maintained: the morality of work. But to think like Rand Paul has the unhappy effect of turning compassion on its head.

In common use, then, ideology means a distortion of the symbolic world in which we live, a distortion

with obvious benefits to a minority. Ideology is a network of stories through which a class of people asserts its common interests. Of course, the first response of ideologues is to say that their claims are not stories at all but simply the way things are. These claims merely describe reality. In particular, scientists become defensive when they are called ideologues. They say that their only interest is the impartial pursuit and establishment of knowledge. But the idea that science works in ideological innocence is the largest of the delusions to which this book's title refers.

For most of its history, science ideology was limited to the insistence that its empirical methods were the only fully adequate way to understand the world. This is often called the Galilean worldview, and goes something like this: there are objects "out there," these objects are mechanically related, and mathematics provides the truth of these mechanical relations. This ideology had important consequences, especially in England and the United States. Chief among these consequences in the nineteenth and early twentieth centuries was the destruction of any vestiges of continental philosophy, especially the German philosophical tradition begun by Kant and continuing through Hegel, Marx, Nietzsche, and even Christian theologians like Paul Tillich, all of whom were dismissed

as "metaphysicians." The Germans were deeply skeptical of the mechanistic worldview of science, and their thinking about capitalism tended toward the revolutionary.

German philosophy was replaced in the Anglo-American world by a philosophy—initiated by Auguste Comte's "positivism" in the mid-nineteenth century—that argued that the hard sciences were the best model for the establishment of truth. In due course, we were given logical (or neo-) positivism, Bertrand Russell's mathematical empyrean, and the so-called analytic school of philosophy. Say what you like about the contemporary relevance of philosophy (the scientists I investigate here seem to think that it is dead) analytic philosophy has provided the invaluable service of eliminating the German philosophical tradition, and eliminating an important form of social critique and dissent in the process. That is something that capitalism can only be very happy about.

To this day, some scientists and philosophers continue to dismiss continental philosophy, as when Richard Dawkins lambasts Michel Foucault and "Francophonyism."

As we well know, the science ideologues of the present do not feel restricted to the mere advocacy of

mechanistic materialism over German metaphysics. They now feel competent to make judgments about every sort of thing, no matter how far afield from their own expertise. Worse yet, they arrogate to themselves the right to speak as representatives for *all* of science and reason, as if their views on religion or philosophy were the universally accepted scientific perspective. In *The Science Delusion*, I look at two such groups of scientists and science advocates. The first is the so-called New Atheists, such as Richard Dawkins and Christopher Hitchens. The second is the recent wave of neuroscientists who claim that every manner of thing—creativity, religious faith, morality, and even Buddhist meditation—can be explained by brain structure, neurons, and neurochemicals. What's distressing is that if TED talks and Amazon sales figures are any indication, the general public (whatever that is) finds it all very "interesting," as this public often says, as well as good reason for eager anticipation of future discoveries.

What these two camps of science ideologues have in common is the application of science's oldest ideology—Galilean mechanical materialism—to all facets of human reality. Every aspect of who we are is a function of evolutionary genetics or other material

processes. In Daniel Dennett's infamous phrase, we are "moist robots," or, for Richard Dawkins, we are "survival machines—robot vehicles." The idea that we are not different from our own machines has achieved the status of common sense, something everybody knows, in just about all the science writing I have encountered in recent years. For example, Ferris Jabr, blogging for *Scientific American*, feels himself on solid ground when he writes, "Do people, cats, plants and other creatures belong in one category and K'Nex, computers, stars and rocks in another? My conclusion: No. In fact, I decided, life does not actually exist."*

Or look at J. Craig Venter's *Life at the Speed of Light*, a book about "digital life." Venter writes, "Life ultimately consists of DNA-driven biological machines. All living cells run on DNA software, which directs ... protein robots." (6) Venter was one of the leading scientists for the Human Genome Project, and he is not in the least bashful about assuming that he speaks for science as a whole.

Let me take a moment to discuss Venter's book,

* This, Jabr reports, was the result of an "epiphany," an odd word to encounter in this context since an epiphany is a manifestation of Christ's divinity through symbolic acts, such as the turning of water into wine. I admit, had Jesus chosen to do so, turning a cat into a computer would have been equally convincing.

a typical example of the tendency of popular science books to move from the production of science to the production of ideology.

In keeping with most popular science books, Venter begins with a lengthy review of the history that led to the scientific developments that are his immediate interest. Also typical of recent science books, when Venter finally arrives at his real interest he introduces it in the form of a metaphor. Now, since I'm a novelist, I don't object to the use of metaphor. But what is striking is how uninterested Venter is in the fact that the metaphor *is* a metaphor. He is not interested in the complicated problem of what metaphors are—their relationship to language and the symbolic structures in which we live—and the lively possibility that metaphors can carry ideological baggage. In other words, in spite of their pride in their highly developed scientific and mathematical skills, scientists like Venter are lacking a kind of thoughtfulness, or curiosity, that might lead them to wonder why science is so often dependent on metaphor for the description of its discoveries. They are even less interested in the social impact of these metaphors.

Here's how it all works in Venter. First, a lengthy overview of the history of "molecular and synthetic biology" moving from the work of Jacob Loeb (*The*

Dynamics of Living Matter) on "durable machines" (and two-headed worms) to Erwin Schrodinger's *What Is Life?* (1944), a book in which Schrodinger observes that chromosomes must contain a "code-script." This history leads up to the present, when we come to understand that DNA is "the software of life" administered by "protein robots," leading to the discovery that "the basic unit of life, the cell, [is] a *factory* [*my emphasis*], an interlocking series of *assembly lines* [*ditto!*] run by protein machines." (35)

This is not the ordinary and dispassionate language of science. It is an extended metaphor almost Homeric in its breadth. And yet Venter never acknowledges that these are metaphors and certainly never considers whether these are the best possible metaphors for describing the situation at hand.

Let me try to help him. The words "factory" and "assembly line" have connotations beyond the simplistic assumption that a factory is a place where things are made. A factory has working conditions (which are usually boring or dangerous or both) for its most important component, workers; it has an owner, usually a corporation, who must find ways of compensating workers that also yield a profit to it and its stockholders; and it must produce commodities for which there is a ready demand (entering the even

more elaborate world of marketing and the creation of demand). If this is what a cell is like, it's no wonder that they mutate and give the larger robot—that would be us—diseases like cancer.

All that is required to reveal the ideology implicit in Venter's metaphor is to replace it with a different metaphor. Perhaps a cell is not so much like a factory as it is like a *commune*. Ideally, a commune is a place where there are no hierarchies, no exploitation, no values dependent on marketing, and an environment characterized by minimally entropic shared labor.

I *hope* that's what my cells are up to!

Now, I know I have dropped into satirical mode, which leads some critics to complain that I'm cranky, elitist, smug, or very, very angry, but there is a serious point here.* In book after book—all written by accomplished men and women of science—we are encouraged to believe that DNA is software, that our cells are machines, that nature is a factory, and that we are robots. This is the language, then, in which we as a society are most likely to take up the conversation, especially in the absence of an alternate language in which we might contest these conclusions. The

* My defense of satire is a line from Goethe: "It is foolish to wait for fools to be cured of their folly! The proper thing to do is to make fools of the fools!"

rhetoric of machines becomes the "of course" of our assumptions about nature and humanity. *Of course* nature is a factory; *of course* we're part of nature and therefore are machines ourselves; and *of course* there is no real difference between us and the robots. In such a context, why would we think that our world *shouldn't* be structured like a vast machine? And why would we imagine that we should be treated as something more than robots with health-care benefits (or not) at our jobs?

The truths that Venter offers, as Nietzsche put it in "On Truth and Lying in a Non-moral Sense," are a "mobile army of metaphors, metonymies, [and] anthropomorphisms,"* which, "after they have been in use for a long time, strike a people as firmly established, canonical, and binding." Venter and his fellow ideologues seek to create a social condition in which we are all "under the obligation ... to lie in accordance with firmly established convention, to lie *en masse* and in a style that is binding for all."

The ever-enlarging consensus for the last two centuries has been that science is dispassionate, intelligent, and skilled, and thoroughly deserving of

* Interestingly, what Venter does is the opposite of anthropomorphosis. He looks at humans and projects robots on to them. He employs mechomorphism, if I have my Greek straight.

our respect and gratitude for its long and successful fight against superstition, bigotry, and dogma. On the whole, there is a lot of truth in this narrative, even though we know that some scientists do lend themselves in a less than honest way to the interests of tobacco companies, the petrochemical industry, and the Department of Defense. But ideologues like Venter do something different. They *distort* this cultural narrative of trust in science in order to make science the single privileged source of knowledge about all human matters, and to further a worldview that is ever more mechanistic, technocratic, and repressive. They turn the world of scientific openness and curiosity on its head. Through Venter and scientists like him, our liberator becomes our oppressor.

Coincidentally, at about the same time as the publication of *The Science Delusion*, a backlash against both the New Atheists and neuroscience began, led by Thomas Nagel's *Mind and Cosmos: Why the Materialist Neo-Darwinian Conception of Nature Is Almost Certainly False* and Sally Satel and Scott Lilienfeld's *Brainwashed: The Seductive Appeal of Mindless Neuroscience*. And then in June of 2013, adding insult to injury, the neuroscience apostate David Brooks wrote

a *New York Times* op-ed recanting his earlier advocacy (in *The Social Animal* [2011]) of the more extreme claims of the field and suggesting that something called the "mind" can be distinguished from what neuroscience studies, namely the brain. Unhappily, Brooks's own cast of mind makes it difficult for him to say anything beyond platitudes about this "mind."*

Predictably, the backlash created a backlash of its own. Nagel's book was widely condemned by scientists and philosophers alike for offering aid and comfort to creationists. Steven Pinker tweeted that Nagel's book was "the shoddy reasoning of a once great thinker," and Daniel Dennett insisted that the book was "not worth a damn." Jerry Coyne, an evolutionary biologist at the University of Chicago, suggested that Nagel's thinking was the equivalent of astrology. Then Satel and Lilienfield's book was harshly criticized in *The New Yorker* for being extreme itself.[†] Meanwhile, Sam Harris attacked me, calling for a boycott of *Salon* after it ran an excerpt from *The Science Delusion* in which I criticize Christopher Hitchens.

And yet this latest episode in the ongoing public

* "Beyond the Brain," *The New York Times*, June 17, 2013.
† Gary Marcus, "The Problem with the Neuroscience Backlash," *The New Yorker*, June 19, 2013.

spectacle of the Anglo-American Culture Wars has had only the most moderate consequences. Science is asked to temper its more extravagant claims, divergent perspectives are given room to express reservations, and humanists fall all over themselves to make it clear that they are not anti-science. In fact, humanists look forward to becoming more scientific themselves through the creation of programs such as the Digital Humanities (Stanford University) and Cognitive Literary Studies (Brown University).

In fact, the first fruit of the digitized humanities has begun to appear. English researchers data-mined the words from three million English-language books in order to create a Literary Misery Index, which showed, in essence, that in bad economic times novelists use more sad words than happy words. (John Steinbeck's *Grapes of Wrath* is a really, really obvious case in point.) Perhaps the humanities will survive by using data-mining and supercomputers to discover bromides and tautologies ("sad times produce sad words"). Theodor Adorno once commented, "Better no art at all than socialist realism," which should now be updated to: "Better no humanities at all than digital humanities."

Still, the backlash against the more extravagant

claims of neuroscientists may be having some effect. For instance, on January 7, 2013, *The New York Times*'s Science Times section ran an article by James Gorman titled "The Brain, in Exquisite Detail," in which he describes the work of the Human Connectome Project at Washington University in St. Louis. This caught my eye because, in the work before you, I critique Sebastian Seung's TED talk on the connectome. As you will have seen, I am most critical of Seung's insistence that connectomes, the "wiring" of our neurons, make us who we are (the subtitle of his book is *How the Brain's Wiring Makes Us Who We Are*).

But after a lengthy account of the work of the scientists at Washington University, Gorman issues some very emphatic caveats. However "exquisite" the details provided by MRIs, the brain remains "elusive." He writes:

> We are not going to "solve the brain" anytime soon—not going to explain consciousness, the self, the precise mechanisms that produce a poem . . . The difficulty of comprehending the brain may be more aptly compared to a poem by Wallace Stevens, "13 Ways of Looking at a Blackbird." Each way of looking, not looking, or just being in the presence of the

blackbird reveals something about it, but only something.*

This is good to hear because "solving the brain" is exactly what the rhetoric of neuroscientists such as Seung and science journalists such as Jonah Lehrer asserts.†

In addition, reports in the media concerning the difficulty scientists face in reproducing experimental results have recently increased.‡ Most notoriously, C. Glenn Begley and Lee M. Ellis, in a paper published in *Nature*, reported that they were not able to reproduce results for forty-seven out of fifty-three landmark cancer studies. In 2005, Dr. John P. A. Ioannidis wrote a similar paper titled "Why Most Published

* In a private e-mail exchange with Gorman, he acknowledged that he was certainly aware of the backlash, but that his caution was "pretty much a life-long habit."

† Gorman's caution is still nowhere near universal. The March 2014 issue of *Scientific American* once again bangs the old gong: "The New Century of the Brain: Revolutionary Tools Will Reveal How Thoughts and Emotions Arise." All that's needed is "better technologies to discover how brain activity gives rise to behavior." Perhaps the worst thing is the implication that we'll have to put up with this sort of talk for another eighty-five years!

‡ For examples, see "Scientific Pride and Prejudice," Michael Suk-Young Chwe, *The New York Times*, January 31, 2014, and "New Truths That Only One Can See," George Johnson, *The New York Times*, January 20, 2014.

Research Findings Are False." But it seems as if these reports are being reintroduced now because there is so much more public dispute about how science "facts" are being used by scientists with social agendas. Venter seems particularly vulnerable to such criticism because, after all, what sort of scientific experiment would show that proteins are robots? If you were to ask other scientists to try to reproduce Venter's "results," I hope they'd laugh.

Welcome though they are, qualifications of this sort will not do much to reverse the already well-established cultural narrative that our brains are computers. For such a reversal, stronger measures are required.

This is why I spend so much time in *The Science Delusion* discussing Romanticism, the proto-romantic essays of Friedrich Schiller in particular, as something more than a long-past historical period or a particular style of art making. Romanticism is very much alive and familiar to most of us. It is, first and foremost, the feeling of alienation, of not being part of and not much liking the world in which you are expected to function. And Romanticism is the subversive logic of counterculture, which is not merely something that

happened in the 1960s. The English Romantics were deeply invested in creating alternative social organizations, usually small enclaves of like-minded poets, friends, and lovers (Coleridge and Robert Southey actually made plans for a utopian community in the United States). And in the present, the dream of counterculture is kept alive through events like Burning Man, as well as through the Occupy movement, and indie art, especially music. Radiohead, Bjork, Neutral Milk Hotel, the Elephant Six music collaborative in Athens, Georgia, and thousands of other subcult "points of light," as Bush the First put it, are ultimately part of the Romantic tradition that begins in alienation and ends in counterculture, that begins with rigidly determined social roles and ends with poets, virtuosi, bohemians, and dandies, and continues on through beatniks, hippies, and punks. This tradition, which includes—don't laugh!—the Sex Pistols, the Ramones, and the Butthole Surfers, was substantially the creation of German philosophy (Richard Wagner being the best example of a philosopher-artist who was also a leader of a subcult—the Wagnerians— that transfixed Europe for fifty years).

In spite of my advocacy for the Romantic tradition, I am often accused of having no "positive program." But one of my critics, Monique Dufour (*Social*

Epistemology Review and Reply Collective, November 2013), has articulated my "program," such as it is, with passion and elegance.

> White identifies and aims at a compelling target: the scientific literati—a small specific group of famous celebrity authors whose names and works are disseminated in august venues. White may have many targets in his book, and they are sometimes diffuse, but this one is clear ... Why should we take them at their word about the meaning of scientific discovery or the truth of beauty? ... In short, why are we obliged to listen, nod, and obey? The answer is scientism ... By the logic of scientism, elite science and reason authorizes the scientific literati to speak (down) to others about all manner of cultural matters, and it allows them to mock, condescend to, and dismiss those who disagree ... Not only do they expect and get a platform from which to speak and be heard, they expect consent ... In response, White suggests the disruptive function of Romantic art.

Dufour acknowledges that my suggestion is

unlikely to send people into the street with torches, but stimulating that sort of revolt was never my intent. What I have intended is to help others create an "outside"—a language, a way of thinking, a kind of action—that is crucial to forming not revolutions of the torch-lit variety but countercultures. Call me modest, but my appeal is to the power of thinking and living differently, not to revolution. It is the politics of refusal. It is the logic of counterculture which is, in the end, a demand to change consciousness and interpret reality in another way.

In his 1984 masterpiece *The Mind of Clover*, Robert Aitken laments the decay of Zen Buddhist culture in Asia.

Today the delusions of greed, hatred, and ignorance fuel industrial and political systems that threaten the very structure of life. Air, water, and food are depleted and poisoned, and the machine of death and destruction accelerates. The dojo has always been a retreat and training center, but now the emphasis must be upon training ourselves as a danaparamita community to become *a new growth within the shell of the old society.*

The Romantic tradition has never been about carrying torches in the street. It was and is about creating "new growth" within a fallen world.

In 1970, the economist Albert Hirschman wrote a book titled *Exit, Voice, and Loyalty*, about the choices that are available to people who are unhappy with a given state of affairs. Hirschman's primary interest is in the behavior of disgruntled customers, but he also sees the broader political implications of his idea. "Loyalty" is the consent of subjects to the status quo. This consent is generally achieved through effective storytelling (ideology, advertising, propaganda) that can be both emotional (patriotism, religion) or rational (science-based claims to what is natural or normal).

"Voice" is the first and least dangerous form of dissent: subjects can offer criticism that amounts to saying that the state's stories don't match the situation on the ground ("equal opportunity for all" is belied by rigid economic stratification), and they can suggest remedies (like New York Mayor Bill de Blasio's idea that a tax should be placed on the wealthy to pay for education for the poor). The established order can attempt to persuade the dissenters that what

they want is wrong, or, if its ideology is flexible, it can join the dissenters to a degree and assimilate or coopt aspects of the dissenter's perspective (the culture and protests of the 1960s were mostly handled in this way). But the establishment can also use force, which can lead to revolution and war (as we've seen in Syria and Ukraine, where peaceful demonstrations were brutally suppressed, leading to what promises to be decades of violence). Revolutions are mostly the consequence of situations in which people are not allowed to use "voice." Revolution is a dire form of voice.

Finally, there is "exit." Subjects can flee the country, or if they can't flee (as with life behind the Iron Curtain) and they cannot safely use their voices, then they will "exit" by refusing to participate (low voter turnout is often symptomatic of this form of refusal). Or they can find a way to start over through utopian gestures as we saw with the Romantics and their art communities, and more broadly and practically in the 1960s through the creation of a variety of countercultures and communes. By these means, we become joyful members of what Martin Luther King, Jr., called the International Association for the Advancement of Creative Maladjustment.

WORKS CITED

Abrams, M. H. *The Mirror and the Lamp.* Oxford University Press, 1953.

Adorno, Theodor. *Metaphysics.* Stanford University Press, 2001.

Aitken, Robert. *The Mind of Clover.* North Point Press, 1984.

Barthes, Roland. *A Lover's Discourse.* Hill and Wang, 1978.

Batchelor, Stephen. *Confessions of a Buddhist Atheist.* Spiegel and Grau, 2011.

Bellah, Robert N. *Religion in Human Evolution: From the Paleolithic to the Axial Age.* Harvard University Press, 2011.

Berlin, Isaiah. *The Roots of Romanticism.* Princeton University Press, 1999.

Black, Edwin. *War Against the Weak.* Dialog Press, 2012.

Brian, Denis. *The Voice of Genius: Conversations with Nobel Scientists and Other Luminaries.* Basic Books, 2000.

Bronowski, Jacob. *The Ascent of Man.* Little, Brown, 1973.

Brooks, David. *The Social Animal.* Random House, 2011.

Calvino, Italo. *Cosmicomics.* Harcourt, Brace, and World, 1968.

Carlyle, Thomas. *Sartor Resartus: The Life and Opinions of Herr Teufelsdröckh.* Chapman and Hall, 1885.

Chekhov, Anton. *Five Plays.* Oxford World's Classics, 1998.

Damasio, Antonio. *Self Comes to Mind: Constructing the Conscious Brain.* Vintage, 2010.

Dawkins, Richard. *The God Delusion*. Mariner Books, 2008.

Dostoevsky, Fyodor. "Notes from Underground," in *White Nights and Other Stories*. The Macmillan Company, 1923.

Eagleton, Terry. *Reason, Faith, and Revolution: Reflections on the God Debate*. Yale University Press, 2010.

Feynman, Richard. *Six Easy Pieces: Essentials of Physics Explained by Its Most Brilliant Teacher*. Helix Books, 1994.

Fichte, Johann. *The Vocation of Man*. Hackett Publishing Company, 1987.

Fortey, Richard. *Life: A Natural History of the First Four Billion Years of Life on Earth*. Knopf, 1998.

Freud, Sigmund. *Civilization and Its Discontents*. The Hogarth Press, 1930.

Goldstein, Rebecca Newberger. "The Hard Problem of Consciousness and the Solitude of the Poet." *Tin House*, Vol. 13, No. 3.

Gould, Stephen Jay. *Rock of Ages: Science and Religion in the Fullness of Life*. Ballantine Books, 1999.

Gribbin, John. *Science: A History 1543–2001*. Penguin/Allen Lane, 2002.

Haldane, J. B. S. *Possible Worlds: And Other Essays*. Chatto and Windus, 1927.

Hamblin, William J. "The Most Misunderstood Book: Christopher Hitchens on the Bible." *The FARMS Review*, Vol. 21, Issue 2, 2009.

Hawking, Stephen. *The Grand Design*. Bantam Books, 2012.

Hirschman, Albert. *Exit, Voice, and Loyalty: Responses to Decline in Firms, Organizations, and States*. Harvard, 1970.

Hitchens, Christopher. *God Is Not Great: How Religion Poisons Everything*. Twelve Books, 2009.

Holt, Jim. *Why Does the World Exist: An Existential Detective Story*. Liveright, 2012.

Krauss, Lawrence M. *A Universe from Nothing: Why There Is Something Rather than Nothing.* The Free Press, 2012.

Lehrer, Jonah. *Imagine: How Creativity Works.* Houghton Mifflin Harcourt, 2012.

Marcuse, Herbert. *One-Dimensional Man.* Beacon Press, 1964.

Mele, Alfred. *Effective Intentions: The Power of Conscious Will.* Oxford University Press, 2012.

Messiaen, Olivier. Liner notes on *Trois Petites Liturgies de la Présence Divine.* The Musical Heritage Society, 1973.

Mlodinow, Leonard. *Subliminal: How Your Unconscious Mind Rules Your Behavior.* Pantheon, 2012.

Nagel, Thomas. *Mind and Cosmos: Why the Materialist Neo-Darwinian Conception of Nature Is Almost Certainly False.* Oxford University Press, 2012.

Peckham, Morse. *Man's Rage for Chaos.* Chilton Books, 1965.

———. *The Romantic Virtuoso.* University Press of New England, 1995.

———. *Romanticism: The Culture of the Nineteenth Century.* George Braziller, 1965.

———. *Romanticism and Ideology.* Wesleyan University Press, 1995.

Pinker, Steven. *How the Mind Works.* Norton, 1997.

Rosenberg, Alex. *The Atheist's Guide to Reality: Enjoying Life Without Illusions.* Norton, 2011.

Rousseau, Jean Jacques. "The Social Contract," in *Man and the State: the Political Philosophers*, ed. Commins and Linscott. Random House, 1947.

Sagan, Carl. *The Demon-Haunted World: Science as a Candle in the Dark.* Ballantine Books, 1997.

Schelling, Friedrich. *System of Transcendental Idealism.* University of Virginia Press, 1978.

Schiller, Friedrich. *Essays.* Continuum, 1995.

Schlegel, Friedrich. "Atheneum Fragments," in *Classic and Romantic German Aesthetics*, ed. J. M. Bernstein. Cambridge University Press, 2003.

Scott, Paul. *The Raj Quartet: The Jewel in the Crown*. William Morrow, 1978.

Seung, Sebastian. *Connectome: How the Brain's Wiring Makes Us Who We Are*. Houghton Mifflin Harcourt, 2012.

Shelley, Percy Bysshe. "A Defense of Poetry," in *English Romantic Writers*, ed. Perkins. Harcourt, Brace, and World, 1967.

Singh, Simon. *Big Bang: The Origin of the Universe*. Harper Perennial, 2005.

Snow, C. P. *Last Things*. Scribners, 1970.

———. *The New Men*. Scribners, 1954.

Solomon, Maynard. *Beethoven*. Schirmer Books, 1998.

Susskind, Leonard. *The Black Hole War: My Battle with Stephen Hawking to Make the World Safe for Quantum Mechanics*. Little, Brown, 2008.

Urban, Hugh. "Osho, From Sex Guru to Guru of the Rich: The Spiritual Logic of Late Capitalism," in Forsthoefel and Humes, eds. *Gurus in America*. SUNY Press, 2005.

Venter, J. Craig. *Life at the Speed of Light*. Viking, 2013.

White, Curtis. *The Middle Mind: Why Americans Don't Think for Themselves*. HarperSanFrancisco, 2003.

INDEX

atheism. *See* New Atheists

The Atheist's Guide to Reality
 (Rosenberg), 3

Atheneum Fragment (Schlegel),
 67, 189–90, 190n

The Atlantic, 24

Auden, W. H., 115

Augustine, Saint, 167

Barnes, Kevin, 122–23

Barthes, Roland, 25, 155

Batchelor, Stephen, 34

Bates, Henry, 91

beauty of the universe, aesthetic/
 emotional amazement at,
 16–23, 87–88, 193–94, 198
 and brain scan images, 107–9
 Dawkins on, 16–23
 and dissonance, 193–95
 extra-scientific values, 18, 23
 poetry and, 153–56
 Poincaré on, 87–88
 and Romanticism, 21, 87–88,
 155–56
 scientists and science writers,
 16–23, 87–88, 107–9, 193–94

Beeman, Mark, 112–13

Beethoven, Ludwig van, 70–71,
 87, 115, 117, 185–88
 Diabelli variations, 70–71
 the Ninth Symphony, 185–86

Bellah, Robert N., 32

Bellarmine, Robert, 97

Berlin, Isaiah, 6–7, 58

Beyond Good and Evil (Ni-
 etzsche), 41

Big Bang, 51–52, 76, 96, 166

Big Bang (Singh), 20, 88

The Big Chill (film), 197

The Birth of Tragedy (Nietzsche),
 137–38

Black, Edwin, 43n

The Black Hole War (Susskind),
 94–95

Blake, William, 41

Boccaccio, Giovanni, 155, 190

Boethius, 170

Bohr, Niels, 94

The Book of Rajneeshism, 33

Borges, Jorge Luis, 103

Brahe, Tycho, 97

brain. *See* neuroscience

Brain and Creativity Institute at
 the University of Southern
 California, 131

Bronowski, Jacob, 44–45, 92–94,
 97, 178

Buber, Martin, 29

Buddhism, 33–34, 134, 136n, 167

Burroughs, William, 145

Byron, Lord, 59, 72–73, 190n

Caldicott, Helen, 44

Calvino, Italo, 77

Cambridge University, 14, 15n, 98

capitalism
 and conscience, 38–39
 and scientism, 11

Carlyle, Thomas, 42n, 49n, 73,
 79n, 190n
 man as symbol-maker, 75, 102,
 180

Rousseau, Jean-Jacques, 62, 63
Ruskin, John, 156
Russell, Bertrand, 25, 157–58, 177

Sagan, Carl, 19
"The Sand Man" (Hoffmann), 5
Sannyasa movement, 33–34
Sartor Resartus (Carlyle), 75, 79n,
 190n
Schelling, Friedrich, 156, 168–88
 on art and philosophy, 183–88
 critique of empiricism/objec-
 tivism, 171–73
 on purpose of philosophy,
 172–73
 temporal schema for develop-
 ment of consciousness/the
 self, 173–81
Schiller, Friedrich, 61–73, 75, 122,
 148, 184
 "Ode to Joy," 186
 and play, 189
 secular dialectic, 61–73, 148
Schlegel, Friedrich, 67, 189–90
Schoenberg, Arnold, 187
Schopenhauer, Arthur, 169, 184
Science: A History (Gribbin), 80,
 99
scientific method
 and neuroscience's approach to
 creativity, 107
 and randomness, 94–97
scientism (ideology of science),
 10–11, 57–58, 90–102,
 147–50, 151–67, 193–98
 and capitalism, 11

crimes of science, 43–46
culture of science, 96–99
and electoral politics, 54
Goldstein on, 151–54, 156–60
and language of mathematics,
 152, 154–55, 157–59, 160–61
mechanical materialism and
 reductionism, 104–15, 128–31,
 140–50, 151–67, 171–72, 185
metaphors of, 164–67
place of science in relation to
 power, 44–45, 97, 98–100
post-Enlightenment, 103–4
science and value, 98
social authority of, 137–39,
 147–50
See also neuroscience; scientists
 and science writers
scientists and science writers
 amazement at beauty of the
 universe, 16–23, 87–88, 107–9,
 193–94
 arrogance of, 46–48
 corporate and governmental
 benefactors, 54–56, 196n
 and culture of science, 96–99
 failure to admit existence of the
 unknowable, 53
 hostility to arts and philosophy,
 57
 ignorance of religious scholar-
 ship and religious traditions,
 29–36, 47–48
 insistence on the meaningless-
 ness of life, 80–81
 rejection of philosophical

AN INTERVIEW WITH CURTIS WHITE

by Linda Heuman

Your book is titled *The Science Delusion*, which is clearly a response to the title of Richard Dawkins's book *The God Delusion*. What is the science delusion, and what are its implications for living a spiritually meaningful life?

There is no singular science delusion. One of the biggest challenges in writing a book that tries to question the role science plays in our culture is being visible at all. So the title is a provocation, although an earnest one.

What I criticize is science as ideology, or scientism, for short. The problem with scientism is that it attempts to reduce every human matter to its own terms. So artistic creativity is merely a function of neurons and chemicals, religion is the result of the God gene, and faith is hardwired into our genetic makeup.

Not surprisingly, "spirit" is a forbidden word. Science writers tend to reduce believers to fundamentalists and the history of religion to a series of criminal anecdotes. Richard Dawkins is, and Christopher Hitchens was, particularly culpable in this regard. Any subtle consideration of the meaning of spirit is left out. But of course the history of religious thought is quite subtle, as anyone familiar with Buddhist philosophy knows well. Another good example is the legacy of Christian existential thinkers beginning with Kierkegaard. It seems to me shamefully dishonest not to acknowledge such work.

Both scientism and religious fundamentalism answer the human need for certainty in a rapidly shifting and disorientingly pluralistic world. To what extent are they in the same business?

As your question suggests, the drama of the confrontation between religious fundamentalism and scientism is a confrontation between things that are more alike than they know. Both fundamentalism and scientism try to limit and close down, not open up. Science tends to be vulnerable to the "closed-in" syndrome. Scientists value curiosity, and they value open-mindedness, but they are often insensible to alternative ways of thinking about the world. It's really difficult for them to get outside of their own worldview. This problem is probably created by the way in which we educate scientists. It seems to me scientists need to have a better background in history and the history of ideas, especially if prominent figures like Stephen Hawking are going to pass judgment on that history and say things like "Philosophy is dead."

There is a common assumption that science is not a worldview but simply "the way things are." Along with that assumption goes another: that science derives its authority from its privileged access to how things are—that it launches off from the bedrock of the Real.

The odd thing here is that science itself tells us that it does *not* have a privileged access to things as they are, and that the philosophical paradoxes in its discoveries, especially in physics, are an open acknowledgment of its many uncertainties.

What we have now is this very uncomfortable joining of an ideological assumption that science is fact-based with the actual work of science, something that is highly speculative and whose reality is often only mathematical. For example, physics is deeply dependent on

mathematical modeling, but no one knows why mathematics seems to be so revealing about reality. As the physicists Tony Rothman and George Sudarshan point out in *Doubt and Certainty*, the math equation of the Black-Scholes model used by stock traders is identical to the equation that shows how a particle moves through a liquid or gas. But, as they observe laconically, in the real world there is a difference between stocks and particle movement.

Even something as familiar as Newtonian equations are mathematical idealizations and, as Einstein showed, are inadequate in important ways. And if Newtonian predictions about the movements of things as large as astral bodies are idealizations, what can be said about quanta or strings or the branes strings are said to attach to? These things are *only* numbers. They have no empirical presence at all.

Many assume that logic and reason lead away from religion. How can the systematic study of literature and art affirm religion?

Our culture widely assumes that all reason is empirical reason: a logical development proceeding from an empirical fact. Similarly, we tend to assume that spirit concerns things that are supernatural. But this is not the only way to understand reason or spirit. The essence of the spiritual logic of Buddhism is contained in the four noble truths. There is suffering. Most of this suffering comes from self-interested desire enabled by delusion. This suffering can be stopped. The eightfold path shows how suffering can cease. This is not an appeal to the supernatural, but it is most certainly an appeal to spirit.

The ultimate religious question, the ultimate religious mystery, is not whether or not there is a God. I call myself an atheist because I think that question is silly, childish, and beside the point. The ultimate religious question is "What is compassion?" Or, as Christianity puts it, "What is love?" Compassion is not a quality that can be demonstrated empirically. It is not a thing. It is something that we use

flexibly. It speaks to a quality that we keep very close to us: the *urgency* of kindness. Compassion exists only to the extent that we invest it with the energy of our own lives—"altruism gene" be damned.

This sort of "theo-logic" also exists in the West. If there is a God principle in existential Christianity, it is in its confidence in the ultimacy of compassion. The Protestant theologian Paul Tillich argued that God is the object of our "ultimate concern." When we are claimed by those concerns, we open ourselves to our true nature.

And art since Romanticism participates in a similar logic. Of course, the common assumption is that art is just imagination or entertainment or a waste of time. My point is that *art thinks*, and the history of art for the last two centuries shows that art thinks in very particular ways. Art has its own spiritual logic. It asks: How are we to transcend what Friedrich Schiller calls "the misery of culture," meaning industrial culture in which man is "nothing but a fragment"? For Schiller and the Romantics, the multifold path of art is the way to accomplish the transcendence of this suffering. As Pablo Picasso wrote, "Painting is not made to decorate apartments. It is a weapon of offensive and defensive war against the enemy." As Picasso's *Guernica* or Goya's *The Third of May 1808* show, the "enemy" is cruelty.

Now, in any of these contexts, this is a perverse logic. If you had to judge the situation empirically, I don't see how you could fail to conclude that the "preponderance of evidence," as lawyers like to say, points to the idea that, as O'Brien says in George Orwell's *1984*, the future is "a boot stamping on a human face—forever." But Buddhism comes to the opposite conclusion. Our suffering is proof not of who we are—violent because of "human nature"—but of the fact that we are deluded, that we don't know ourselves, and that if we are to end suffering we must, as Nietzsche says, *become who we really are*. It is the perversity of this logic that makes it spiritual because it is in no way supported by the facts on the ground. It's like the story of the Jew who tells his Christian neighbor that he is going to Rome to see what Christianity is really like. The neighbor, of course, fears that once the

man sees all the corruption there he will not convert. But when his neighbor returns, he says, "Ah, my friend, yours is truly the greatest faith, otherwise it could not survive such cruelty and hypocrisy."

The crucial thing to see in this process of thought is that it is a form of spiritual reason with a basis in realism: our experience of how it is with the human world. True, it is not empirical reason driven by a notionally objective world, but neither are its conclusions dependent on supernaturalism or magical thinking. The idea that all human reason must be empirical is a story that is told to us by our masters.

When critics speak of scientism as an ideology, many seem to be thinking of an ideology as a set of beliefs—like propositions you hold in your head. Your book gave me a sense that ideology, in particular scientism, is much more deeply rooted than that.

I use the word *ideology* in the sense that Marx used it: the stories and ideas that we live out as members of a particular culture. Needless to say, there is a neutral sense in which every culture must have ideologies. The pejorative sense of the term comes from the idea that structures of power and privilege can and do manipulate and enforce these stories in order to support their own interests. The stories stop being concerned with the question "What is the best way for us to live together?" and start being "What stories best support our own interests?" Telling stories that you want everyone to see themselves in, but that really favor only one group, requires dishonesty. So what I am concerned with is identifying those dishonest or false elements within the ideology delivered to us by science and its patrons.

Of course, the primary ideological story told by science is that it has no relation to ideology. But that's what every ideology says. It says, "We are only concerned with the way things really are." And so the science of economics tells us that self-interest is rational, that it is the essence of freedom, and that it may even be a part of our genetic makeup. These become the covering fictions for stupendous

destruction and cruelty. As Buddhism argues, these ideas are not skillful. They are delusions, and they do great harm.

You've written that not only do we have technology, we also have technocracy—which is run by corporatists, militarists, and self-serving politicians.

It is a mistake to think that we just happen to have these toys and gadgets around without trying to understand what their relationship is to the larger culture. One of the first books that spoke to me powerfully as political theory was Theodore Roszak's *The Making of a Counter Culture* (1968). I reread it recently, and it still holds up very well. He wrote, "By technocracy, I mean that social form in which an industrial society reaches the peak of its organizational integration." Theodor Adorno called it "administered society." An administered society is one in which technological rationality and industrial organization have penetrated deeply into every aspect of how we live.

For example, by bringing personal computers into our homes, we also brought our workstations into our homes. And so who knows how many hours a week you work? In a sense, many workers are never not at work, because now they carry their job in their pocket. Or consider service workers in the fast-food industry. These workers are treated not as humans but as a part of a superefficient machine, and the skills required of them are crudely mechanical as well.

The more normalized all of this becomes, the more oppressive—and, needless to say, perversely successful—it is. The result is a culture that is "totalized." Every aspect of the culture is made conformable to a certain technocratic and mechanistic ideal. That's why I say that scientism is such an important part of state ideology. It is doing work for the boss.

(Excerpted from a conversation published in the Spring 2014 issue of Tricycle.*)*